The Official

A GAME
OF
THRONES

Coloring Book

George R. R. Martin

BANTAM BOOKS
NEW YORK

Illustration credits
Yvonne Gilbert: pages 21, 23, 25, 31, 37, 49, 53, 59, 61, 77
John Howe: pages 35, 43, 55, 57, 69, 75, 85, 87, 89, 91
Levi Pinfold: pages 27, 29, 39, 47, 63, 65, 83
Adam Stower: pages 41, 45, 67, 71, 73, 79
Tomislav Tomić: pages 3, 5, 7, 9, 11, 13, 15, 17, 19, 33, 51, 81

A Bantam Books Trade Paperback Original

Copyright © 2015 by George R. R. Martin
Text copyright © 1996, 1999, 2000, 2005, 2011 by George R. R. Martin

Published in the United States by Bantam Books, an imprint of Random House,
a division of Penguin Random House LLC, New York.

BANTAM BOOKS and the HOUSE colophon are registered trademarks
of Penguin Random House LLC.

The text in this work originally appeared in *A Game of Thrones*, *A Clash of Kings*,
A Storm of Swords, *A Feast for Crows*, and *A Dance with Dragons* by George R. R.
Martin, published by Bantam Books, an imprint of Random House, a division of
Penguin Random House LLC in 1996, 1999, 2000, 2005, and 2011 respectively.

ISBN 978-1-101-96576-4

Printed in the United States of America on acid-free paper

randomhousebooks.com

3 5 7 9 10 8 6 4

Book design by Christopher M. Zucker

The Official

A GAME OF THRONES

Coloring Book

Every noble house had its words. Family mottoes, touchstones, prayers of sorts, they boasted of honor and glory, promised loyalty and truth, swore faith and courage. All but the Starks. *Winter is coming,* said the Stark words.

—*A Game of Thrones*

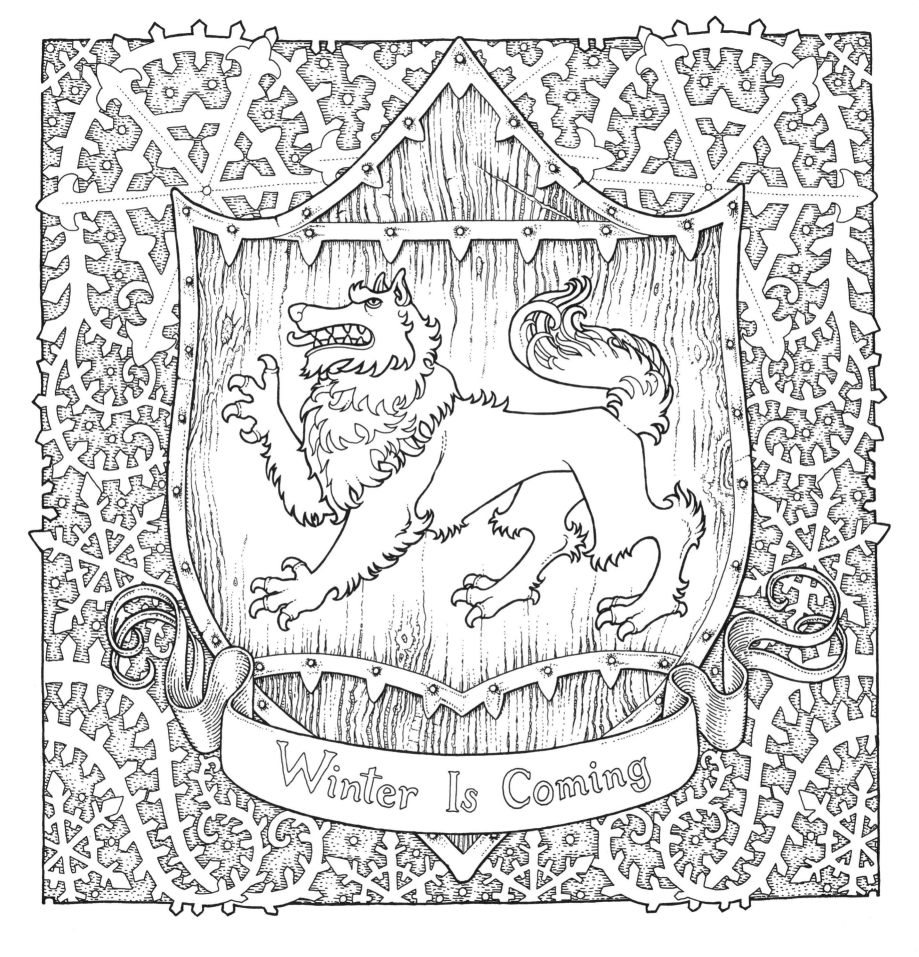

The king's pavilion was close by the water, and the morning mists off the river had wreathed it in wisps of grey. It was all of golden silk, the largest and grandest structure in the camp. Outside the entrance, Robert's warhammer was displayed beside an immense iron shield blazoned with the crowned stag of House Baratheon.

—*A Game of Thrones*

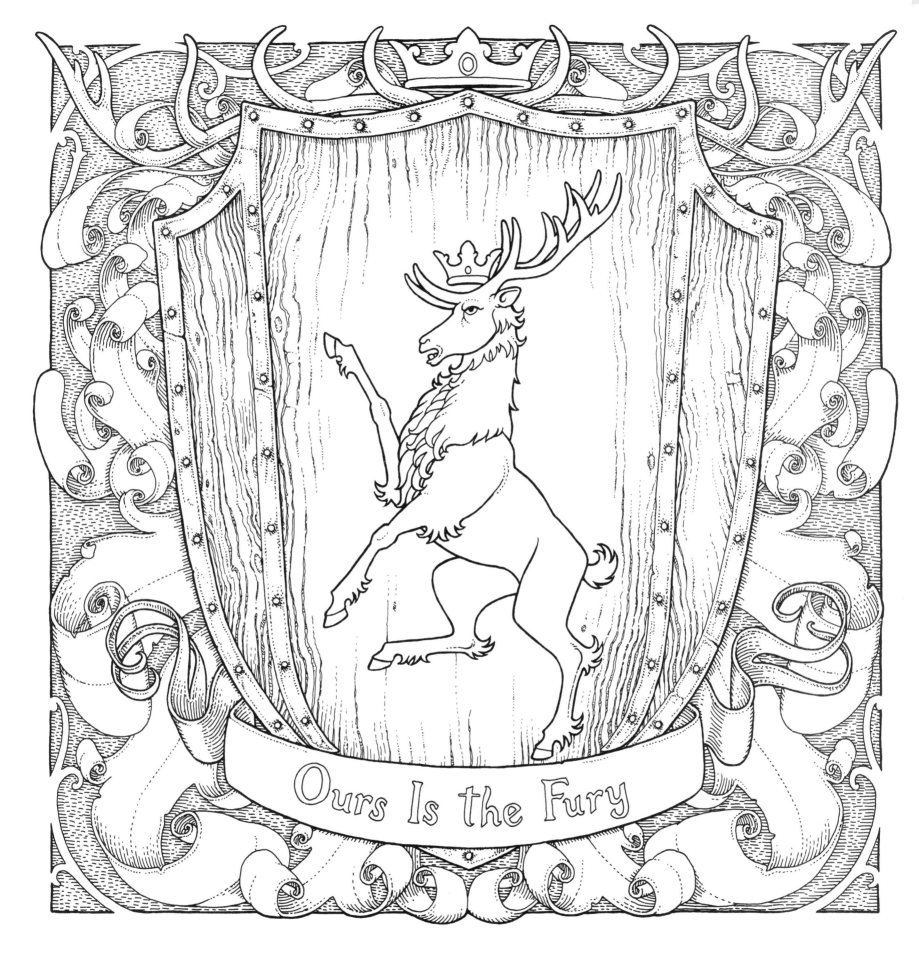

Ours Is the Fury

On a golden breastplate, the lion of Lannister roared its defiance.

—A Game of Thrones

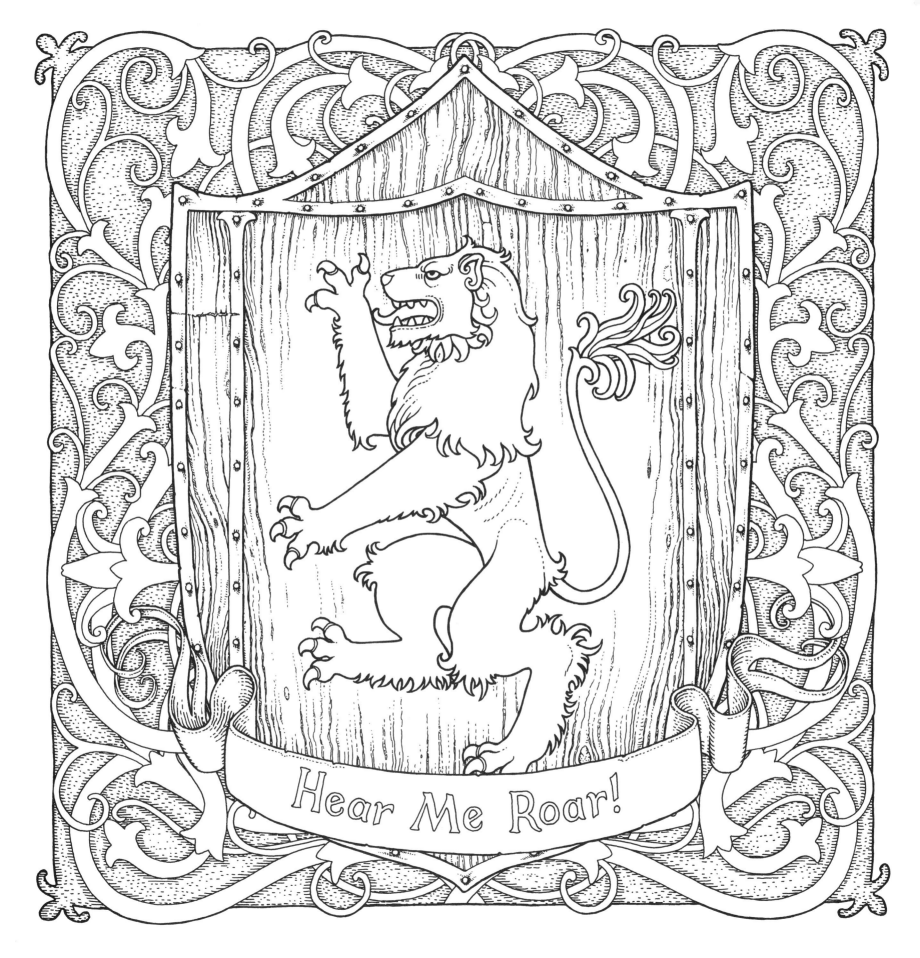

Hear Me Roar!

When the Mad King Aerys II Targaryen had demanded their heads, the Lord of the Eyrie had raised his moon-and-falcon banners in revolt rather than give up those he had pledged to protect.

—*A Game of Thrones*

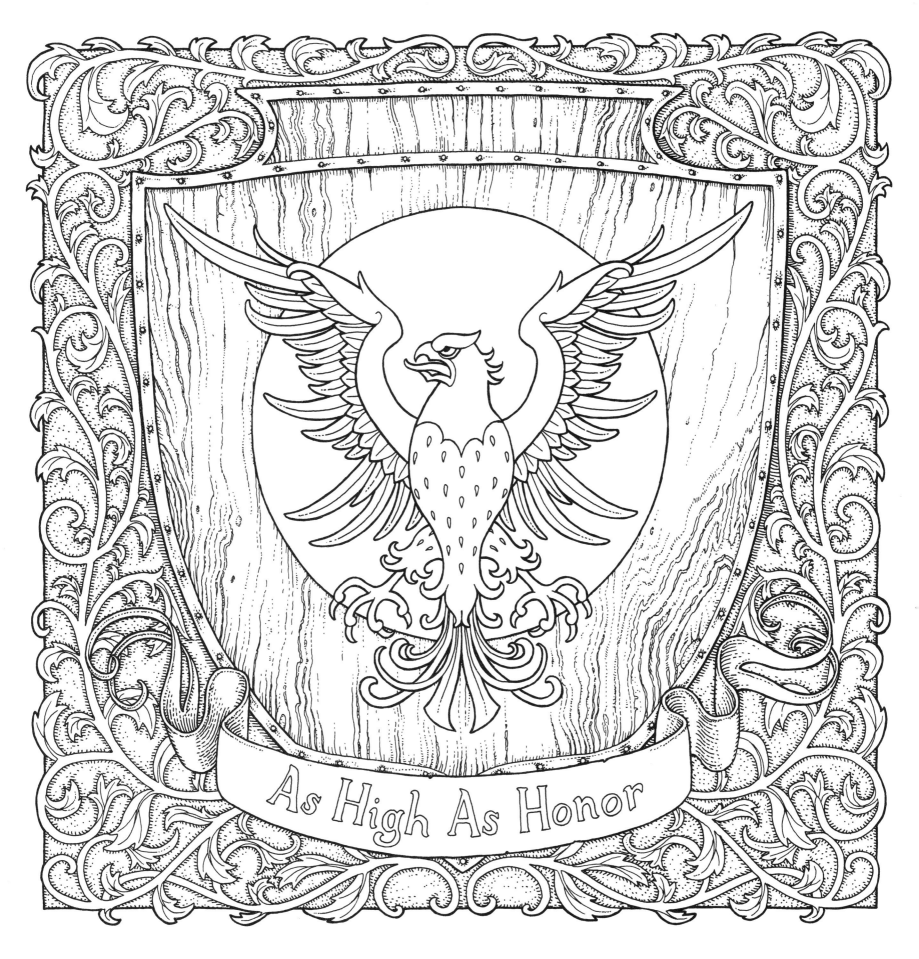

As High As Honor

From every rampart waved the banner of House Tully: a leaping trout, silver, against a rippling blue-and-red field.
 —A Game of Thrones

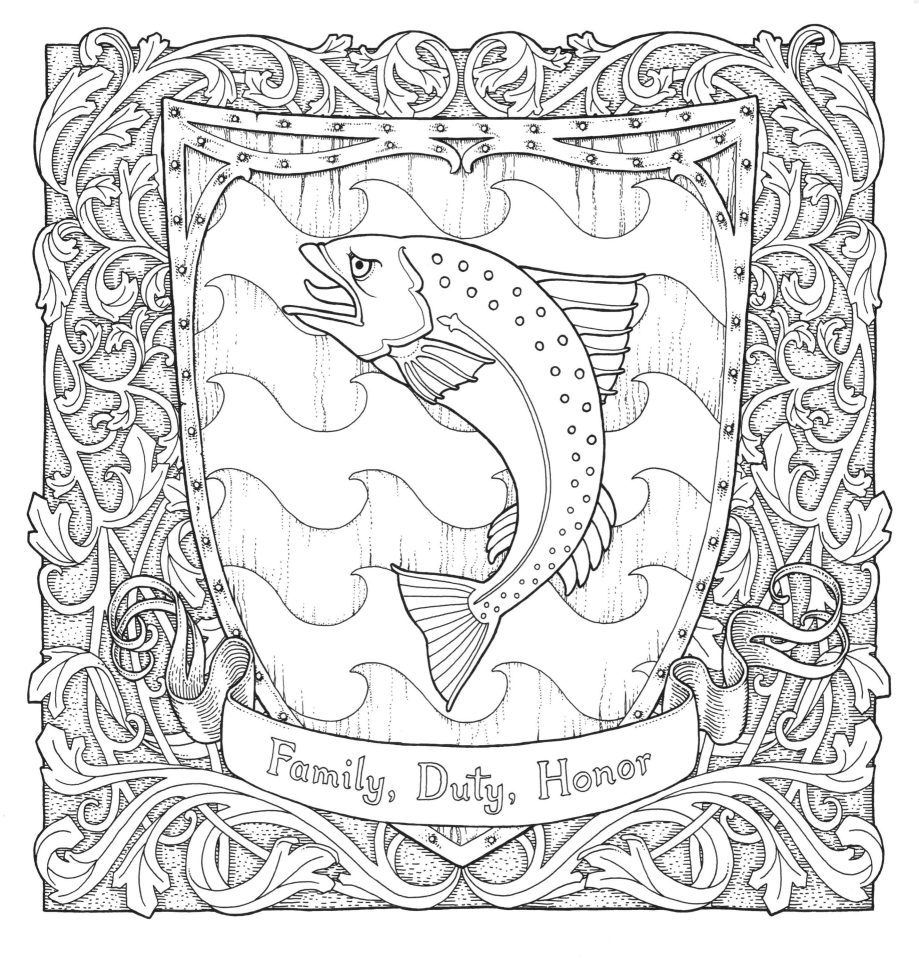

Family, Duty, Honor

Near all the chivalry of the south had come to Renly's call, it seemed. The golden rose of Highgarden was seen everywhere: sewn on the right breast of armsmen and servants, flapping and fluttering from the green silk banners that adorned lance and pike, painted upon the shields hung outside the pavilions of the sons and brothers and cousins and uncles of House Tyrell.

<div align="right">

—*A Clash of Kings*

</div>

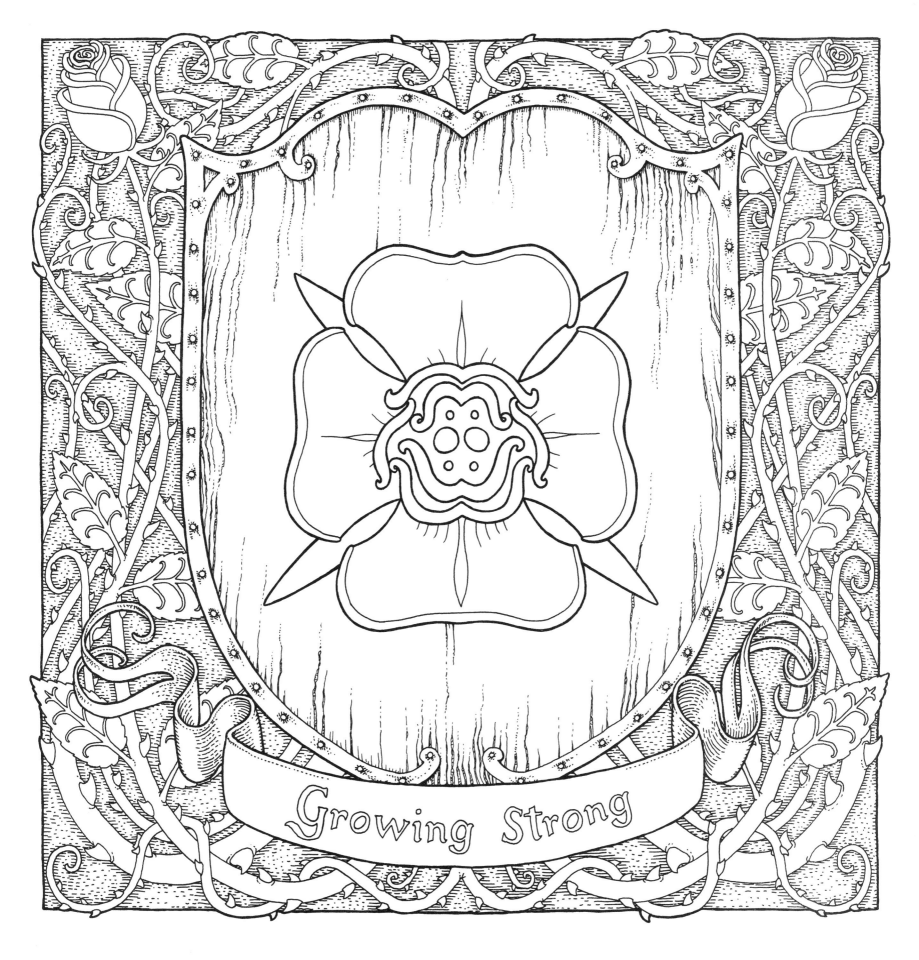

Growing Strong

Above the Sea Tower snapped his father's banner. The *Myraham* was too far off for Theon to see more than the cloth itself, but he knew the device it bore: the golden kraken of House Greyjoy, arms writhing and reaching against a black field. The banner streamed from an iron mast, shivering and twisting as the wind gusted, like a bird struggling to take flight.

<div align="right">

—*A Clash of Kings*

</div>

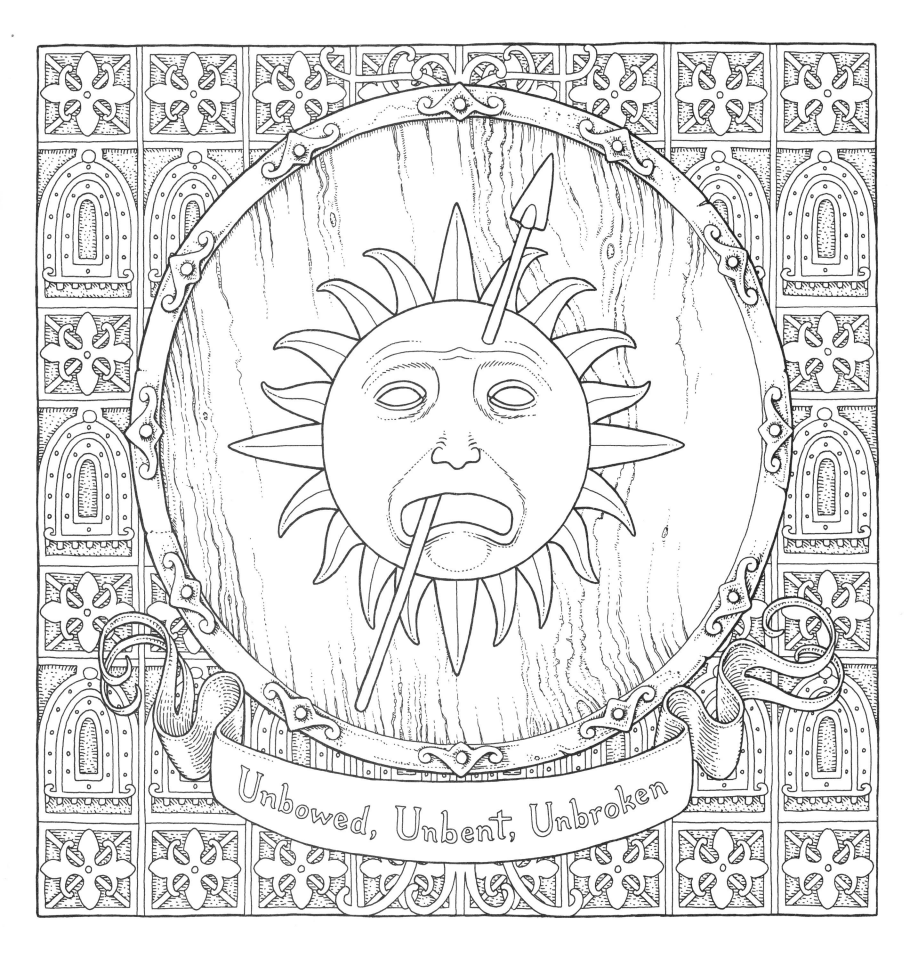

Unbowed, Unbent, Unbroken

They had come together at the ford of the Trident while the battle crashed around them, Robert with his warhammer and his great antlered helm, the Targaryen prince armored all in black. On his breastplate was the three-headed dragon of his House, wrought all in rubies that flashed like fire in the sunlight. The waters of the Trident ran red around the hooves of their destriers as they circled and clashed, again and again, until at last a crushing blow from Robert's hammer stove in the dragon and the chest beneath it.

—*A Game of Thrones*

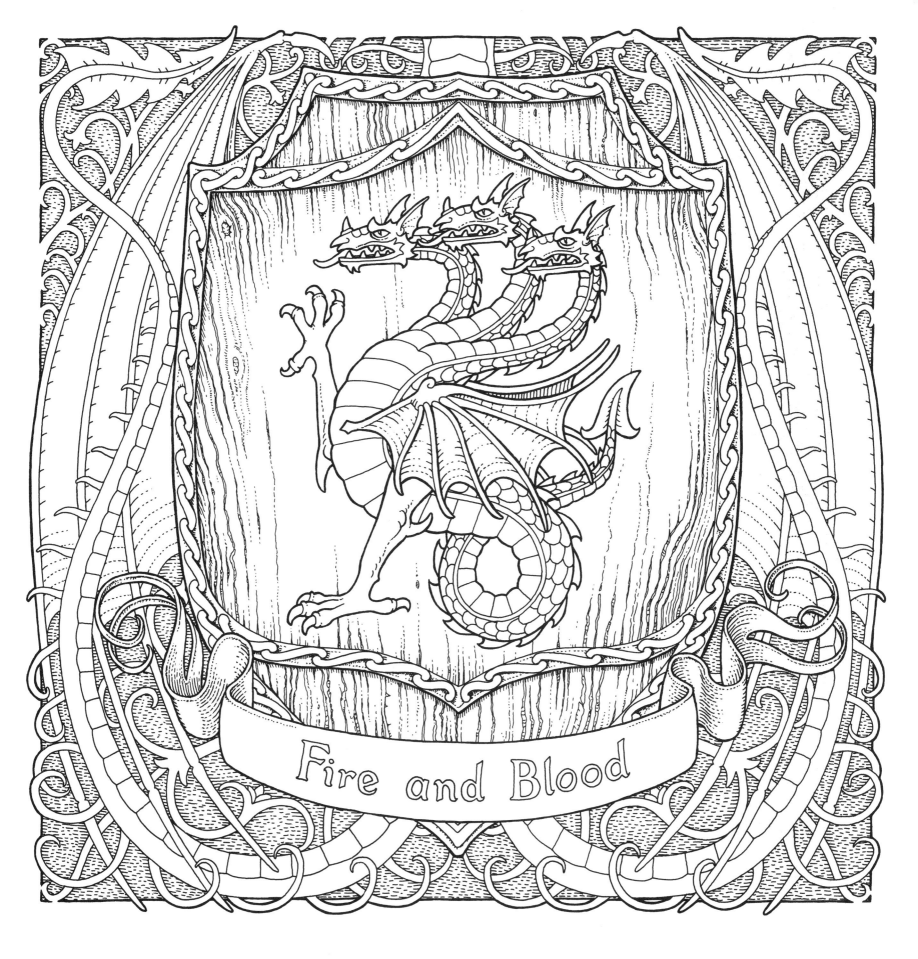

Fire and Blood

His lord father had come first, escorting the queen. She was as beautiful as men said. A jeweled tiara gleamed amidst her long golden hair, its emeralds a perfect match for the green of her eyes.

—*A Game of Thrones*

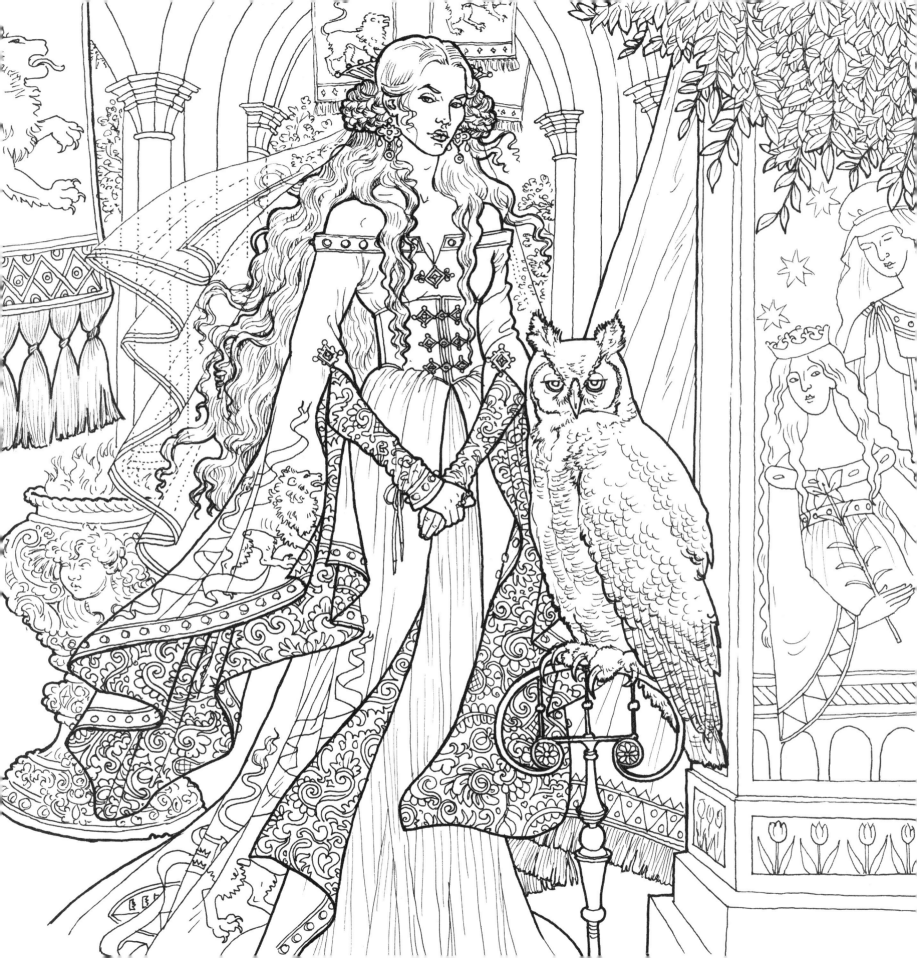

It wasn't fair. Sansa had everything. Sansa was two years older; maybe by the time Arya had been born, there had been nothing left. Often it felt that way. Sansa could sew and dance and sing. She wrote poetry. She knew how to dress. She played the high harp *and* the bells. Worse, she was beautiful.

—*A Game of Thrones*

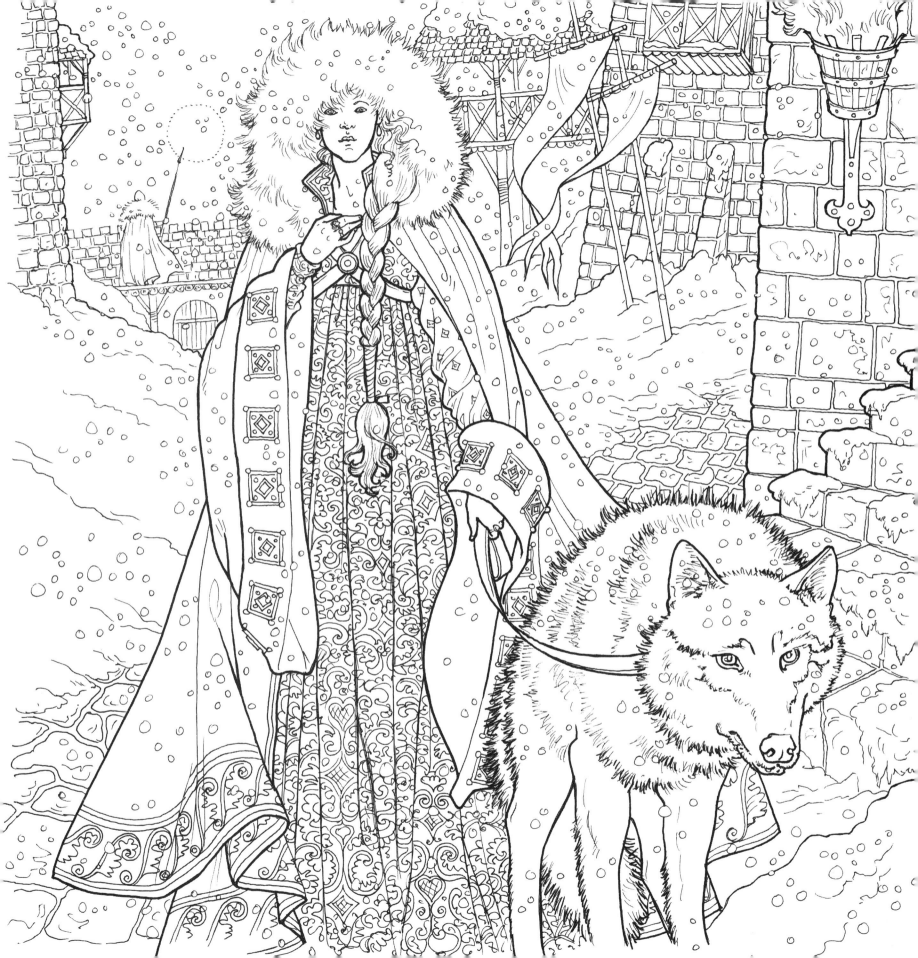

Ser Loras was the youngest son of Mace Tyrell, the Lord of Highgarden and Warden of the South. At sixteen, he was the youngest rider on the field, yet he had unhorsed three knights of the Kingsguard that morning in his first three jousts. Sansa had never seen anyone so beautiful. His plate was intricately fashioned and enameled as a bouquet of a thousand different flowers, and his snow-white stallion was draped in a blanket of red and white roses.

—*A Game of Thrones*

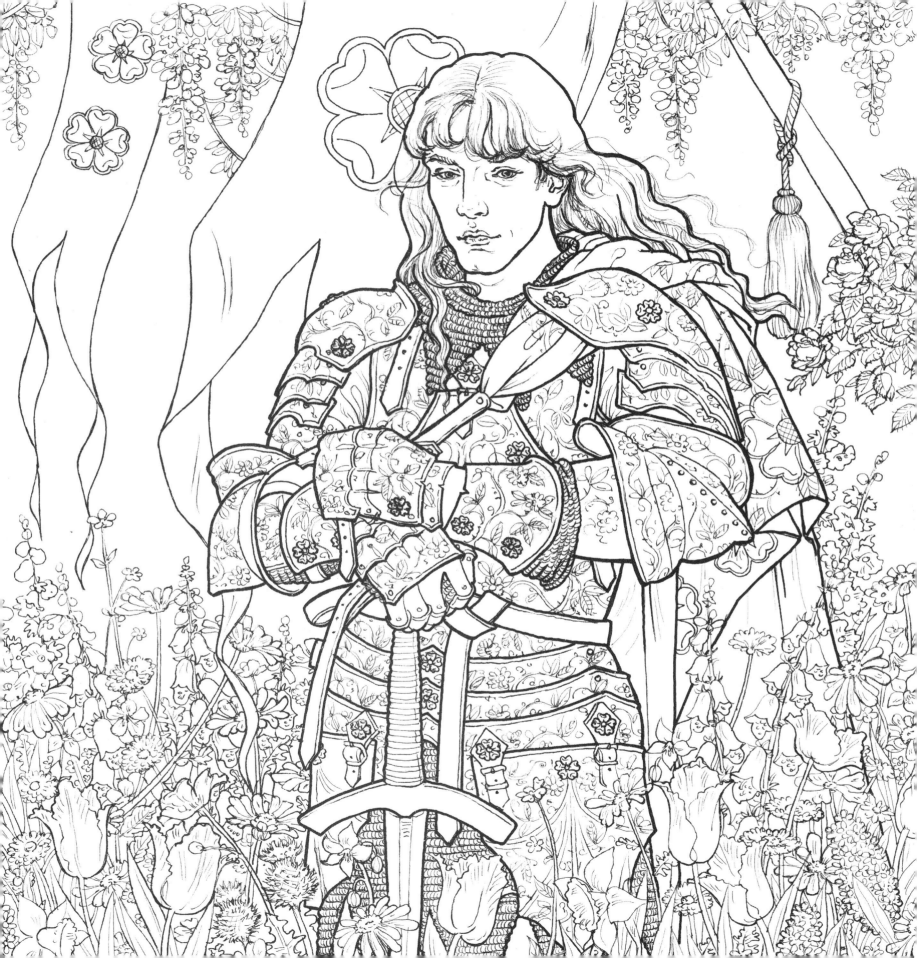

Many called her beautiful. She was not beautiful. She was red, and terrible, and red.

<div style="text-align: right;">—A Clash of Kings</div>

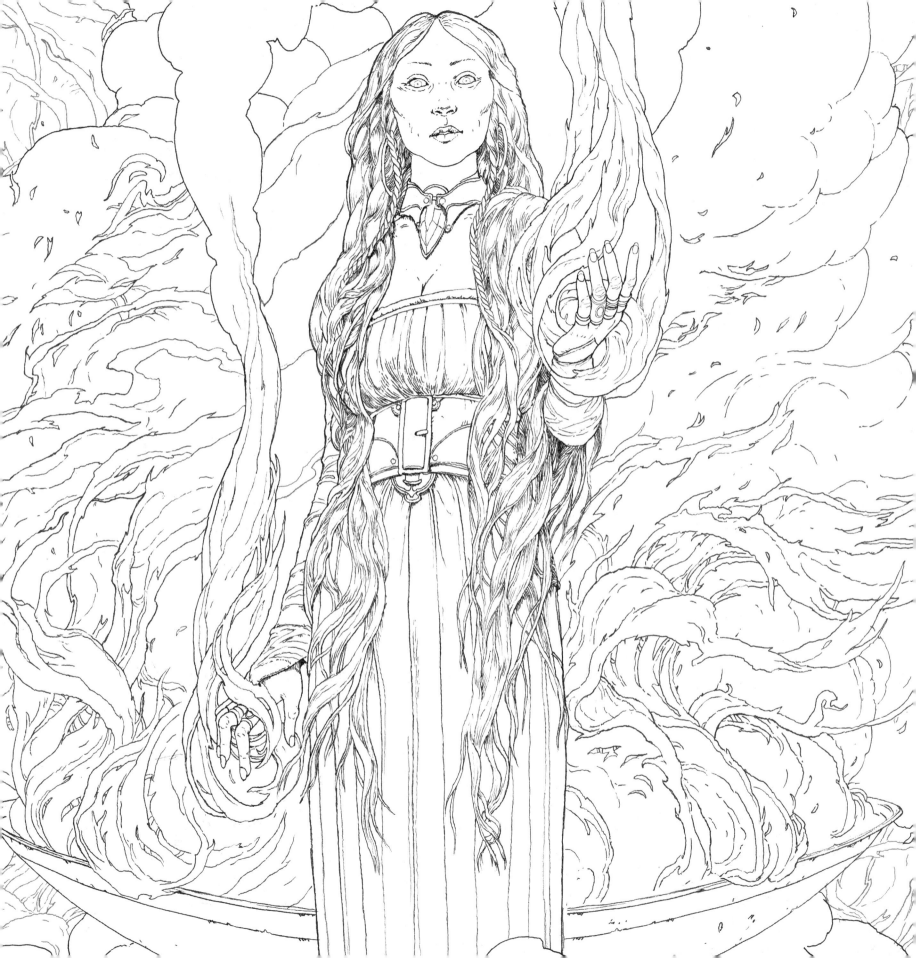

"Nothing happens in this city without Varys knowing. Oftimes he knows about it *before* it happens. He has informants everywhere. His little birds, he calls them."

<div align="right">

—*A Game of Thrones*

</div>

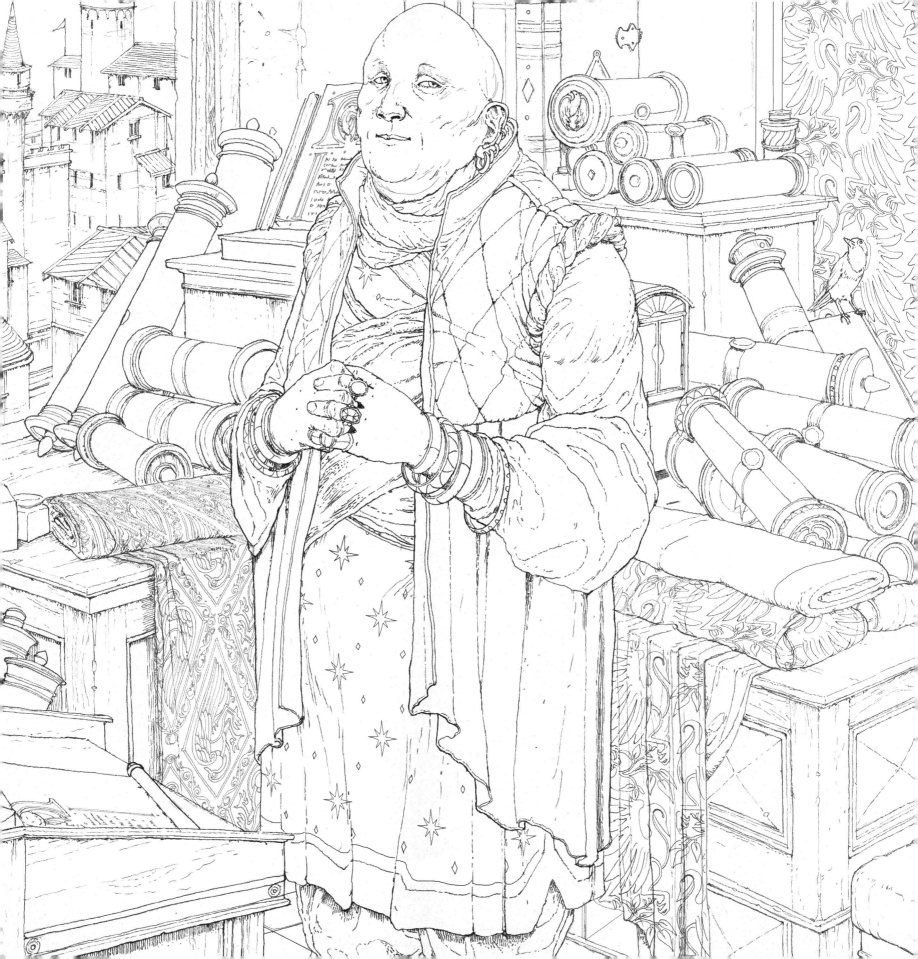

Daario Naharis was flamboyant even for a Tyroshi.

—A Storm of Swords

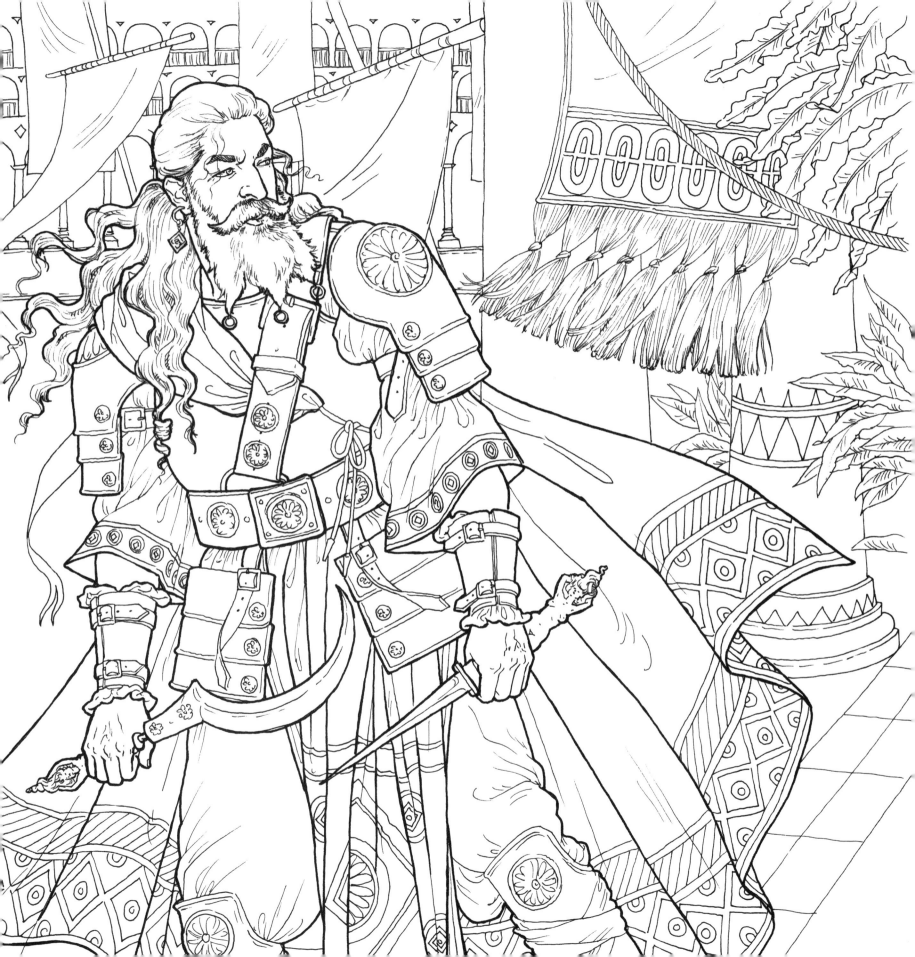

Just ahead, the elk wove between the snowdrifts with his head down, his huge rack of antlers crusted with ice. The ranger sat astride his broad back, grim and silent. *Coldhands* was the name that the fat boy Sam had given him, for though the ranger's face was pale, his hands were black and hard as iron, and cold as iron too.

—*A Dance with Dragons*

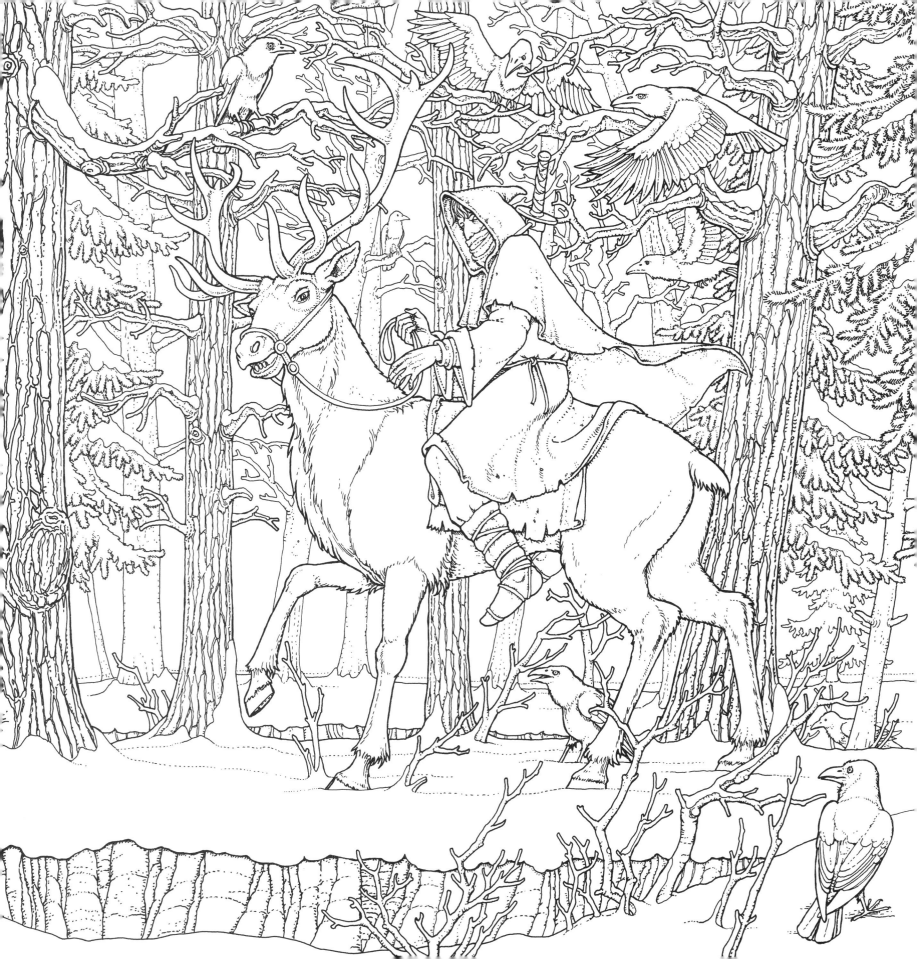

Many were Dothraki horselords, big men with red-brown skin, their drooping mustachios bound in metal rings, their black hair oiled and braided and hung with bells.

<div align="right">

—*A Game of Thrones*

</div>

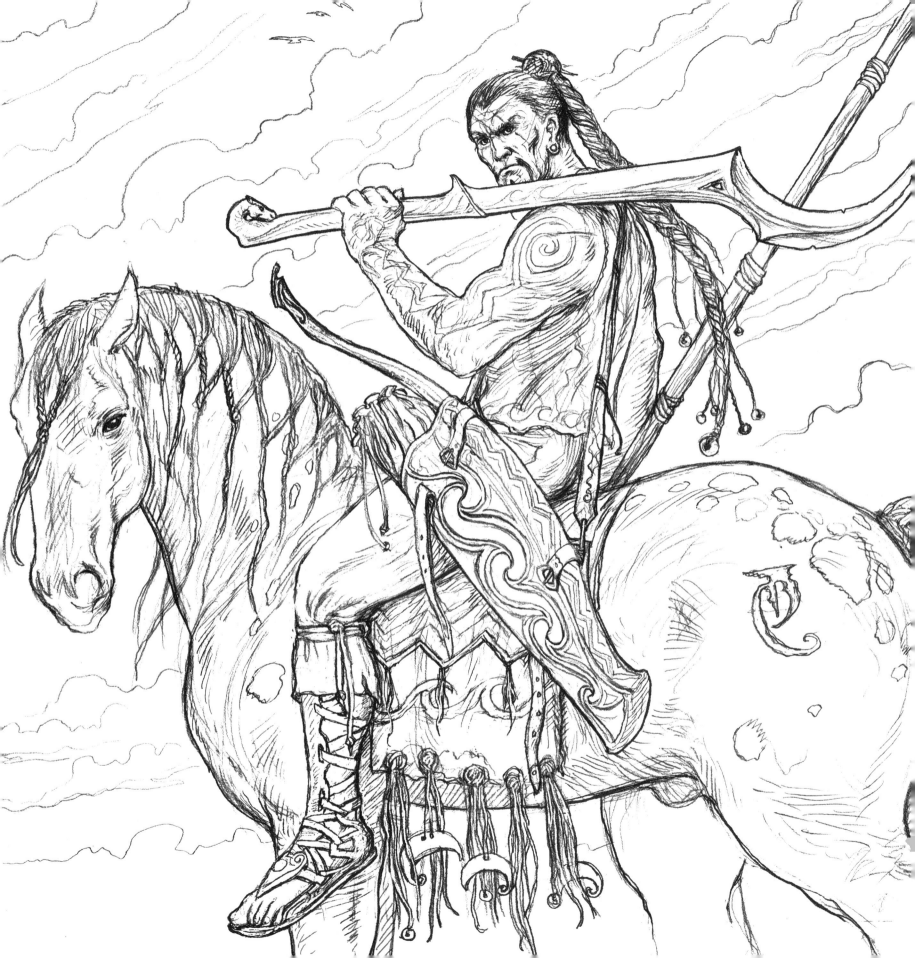

Behind the drum marched Brazen Beasts four abreast.
Some carried cudgels, others staves; all wore pleated skirts,
leathern sandals, and patchwork cloaks sewn from squares
of many colors to echo the many-colored bricks of Meereen.
Their masks gleamed in the sun: boars and bulls, hawks and
herons, lions and tigers and bears, fork-tongued serpents
and hideous basilisks.

—*A Dance with Dragons*

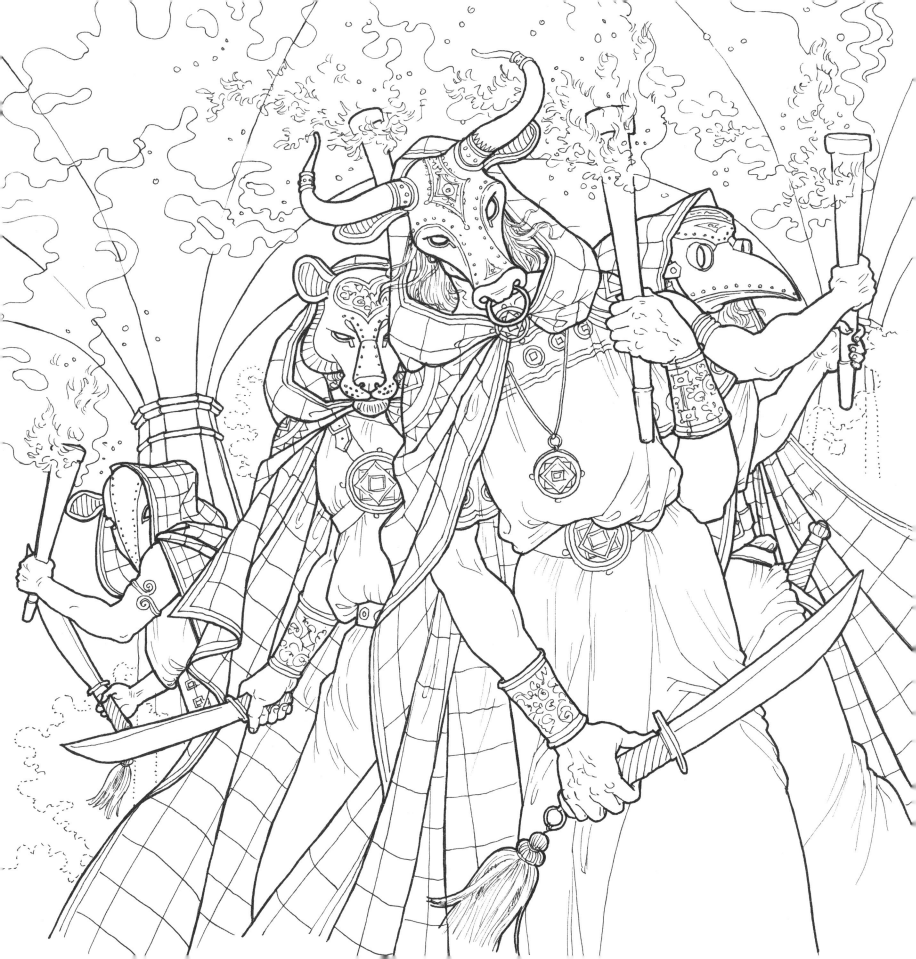

"North of the Wall, things are different. That's where the children went, and the giants, and the other old races."

—*A Game of Thrones*

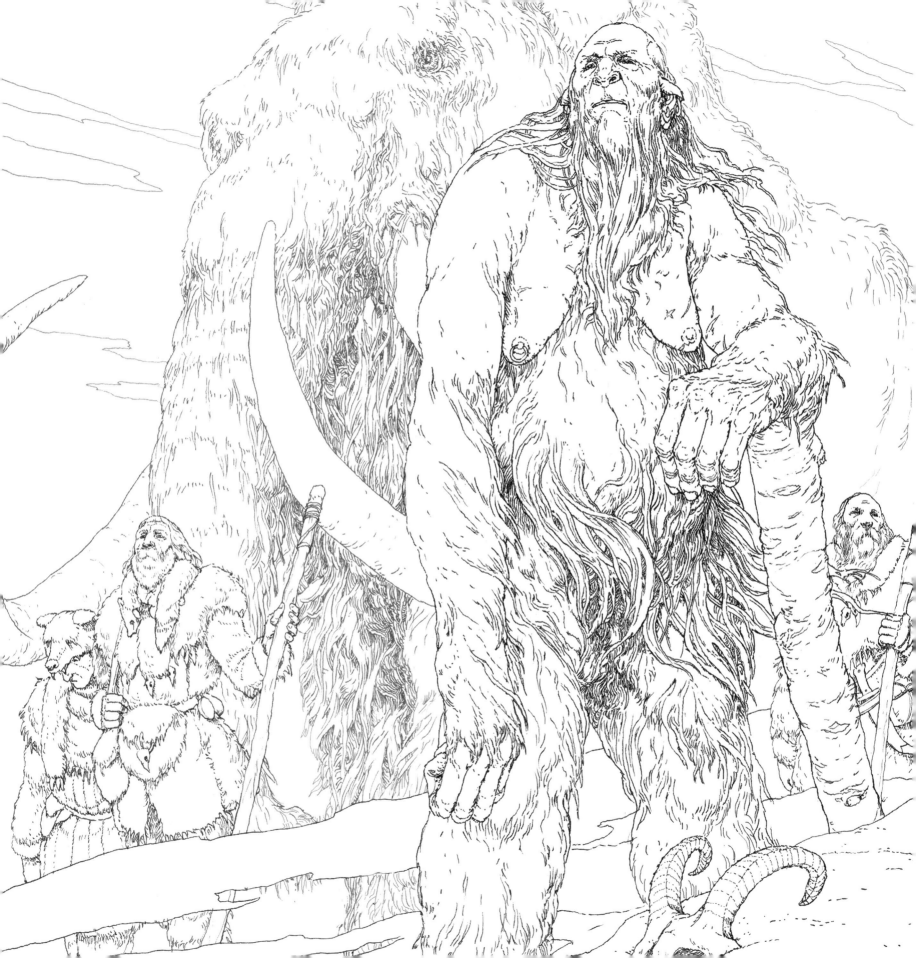

"Bran, the children of the forest have been dead and gone for thousands of years. All that is left of them are the faces in the trees."

—*A Game of Thrones*

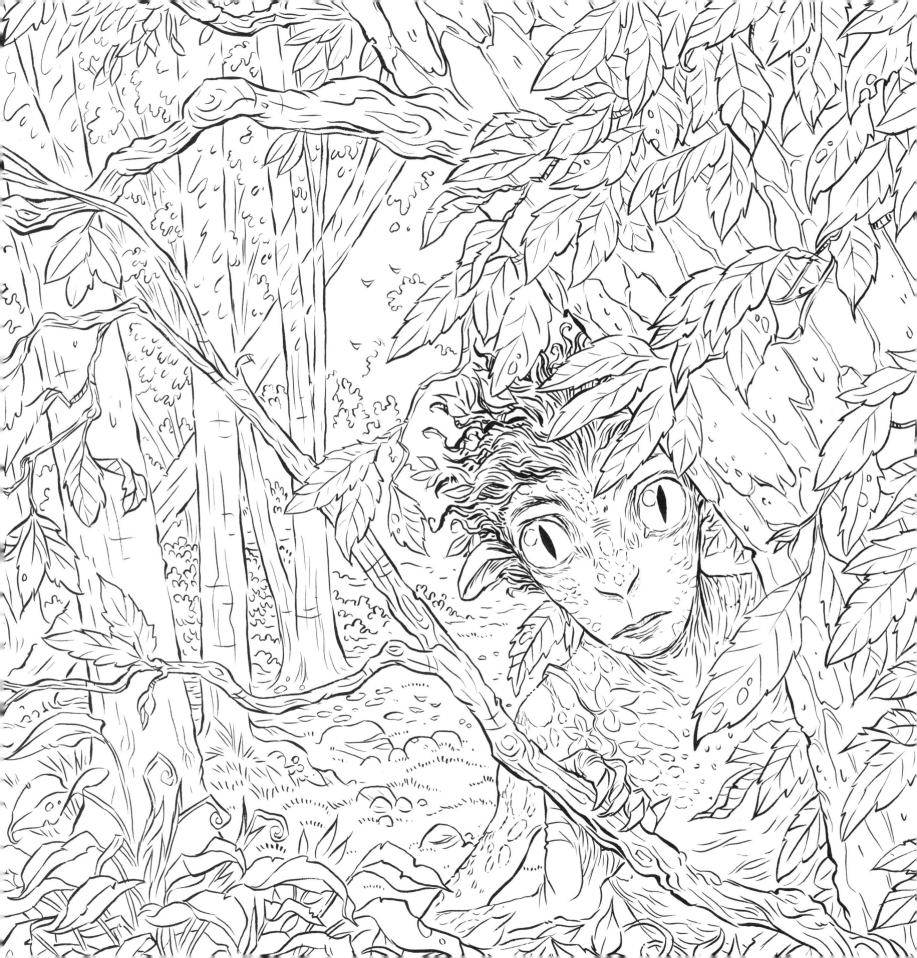

In the south the last weirwoods had been cut down or burned out a thousand years ago, except on the Isle of Faces where the green men kept their silent watch. Up here it was different. Here every castle had its godswood, and every godswood had its heart tree, and every heart tree its face.

—*A Game of Thrones*

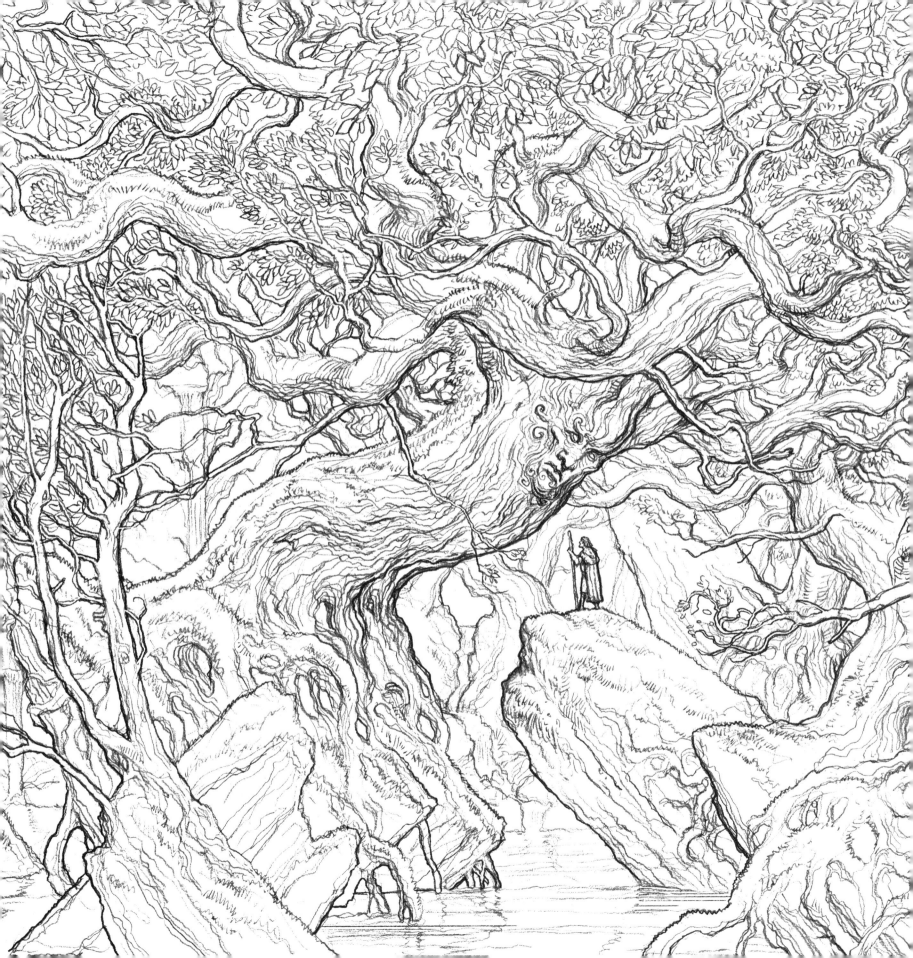

To a boy, Winterfell was a grey stone labyrinth of walls and towers and courtyards and tunnels spreading out in all directions. In the older parts of the castle, the halls slanted up and down so that you couldn't even be sure what floor you were on. The place had grown over the centuries like some monstrous stone tree, Maester Luwin told him once, and its branches were gnarled and thick and twisted, its roots sunk deep into the earth.

—*A Game of Thrones*

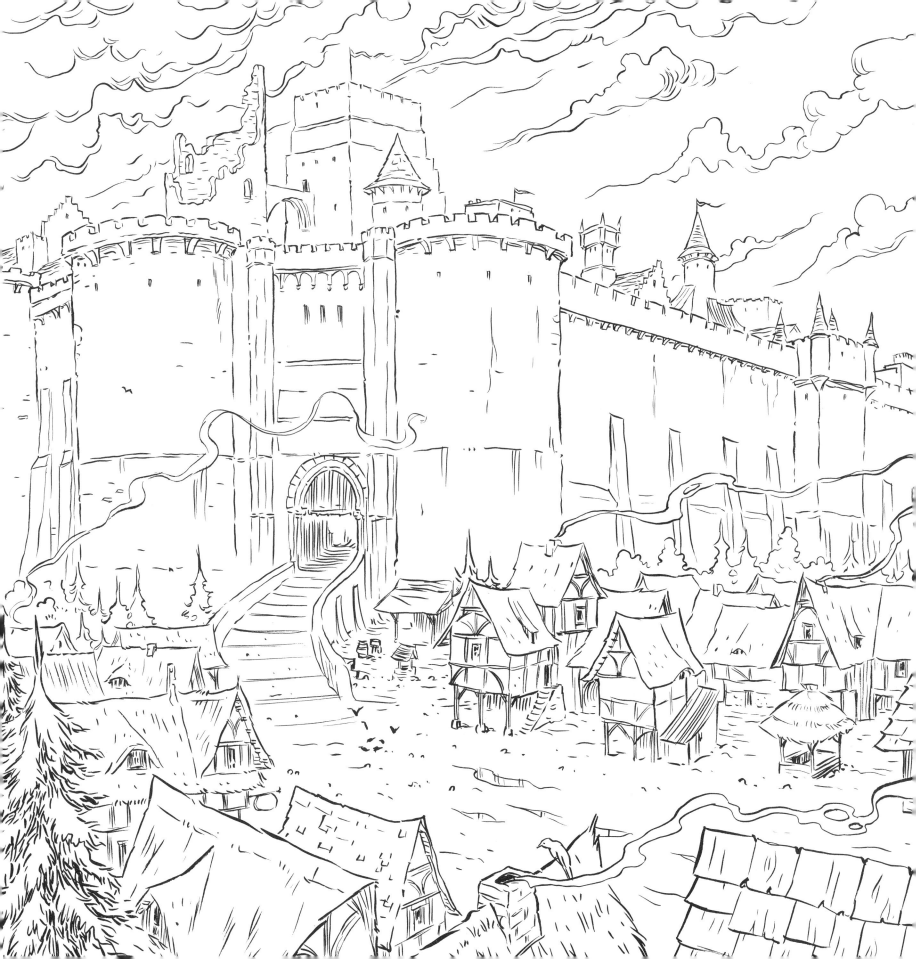

And above it all, frowning down from Aegon's high hill, was the Red Keep; seven huge drum-towers crowned with iron ramparts, an immense grim barbican, vaulted halls and covered bridges, barracks and dungeons and granaries, massive curtain walls studded with archers' nests, all fashioned of pale red stone.

—*A Game of Thrones*

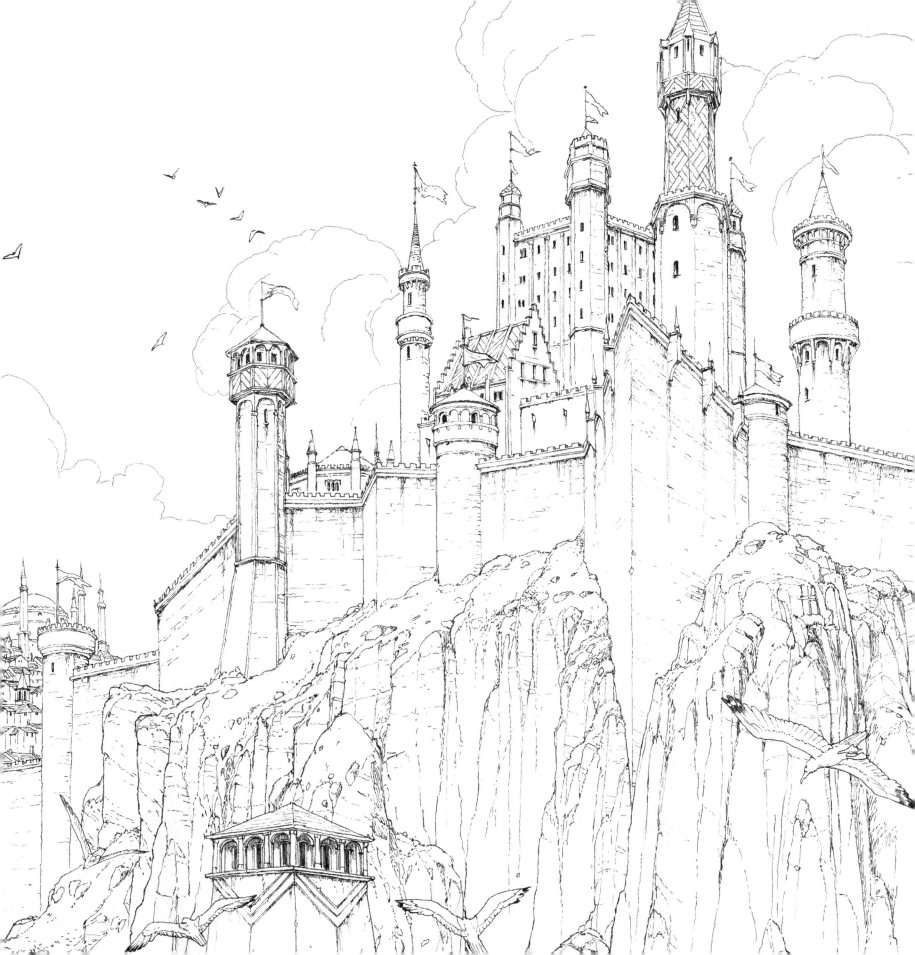

The eastern road was wilder and more dangerous, climbing through rocky foothills and thick forests into the Mountains of the Moon, past high passes and deep chasms to the Vale of Arryn and the stony Fingers beyond. Above the Vale, the Eyrie stood high and impregnable, its towers reaching for the sky.

—*A Game of Thrones*

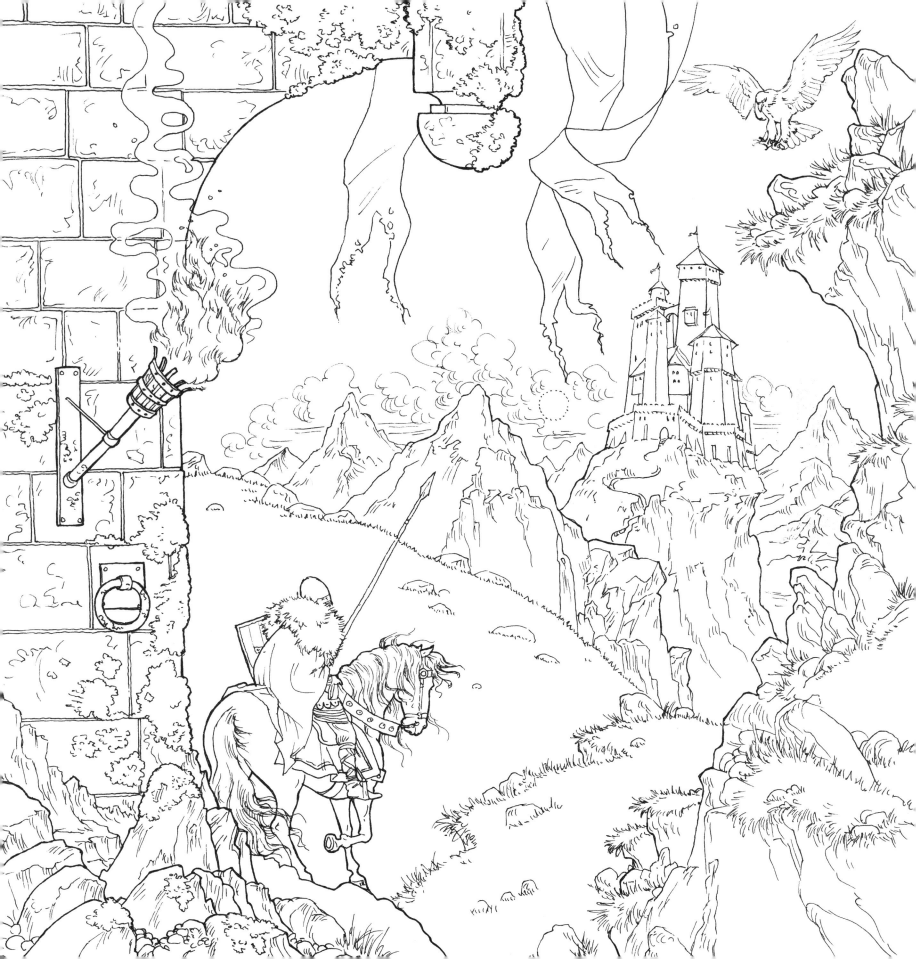

"Sansa, would you like to visit Highgarden?" When Margaery Tyrell smiled, she looked very like her brother Loras. "All the autumn flowers are in bloom just now, and there are groves and fountains, shady courtyards, marble colonnades."

—*A Storm of Swords*

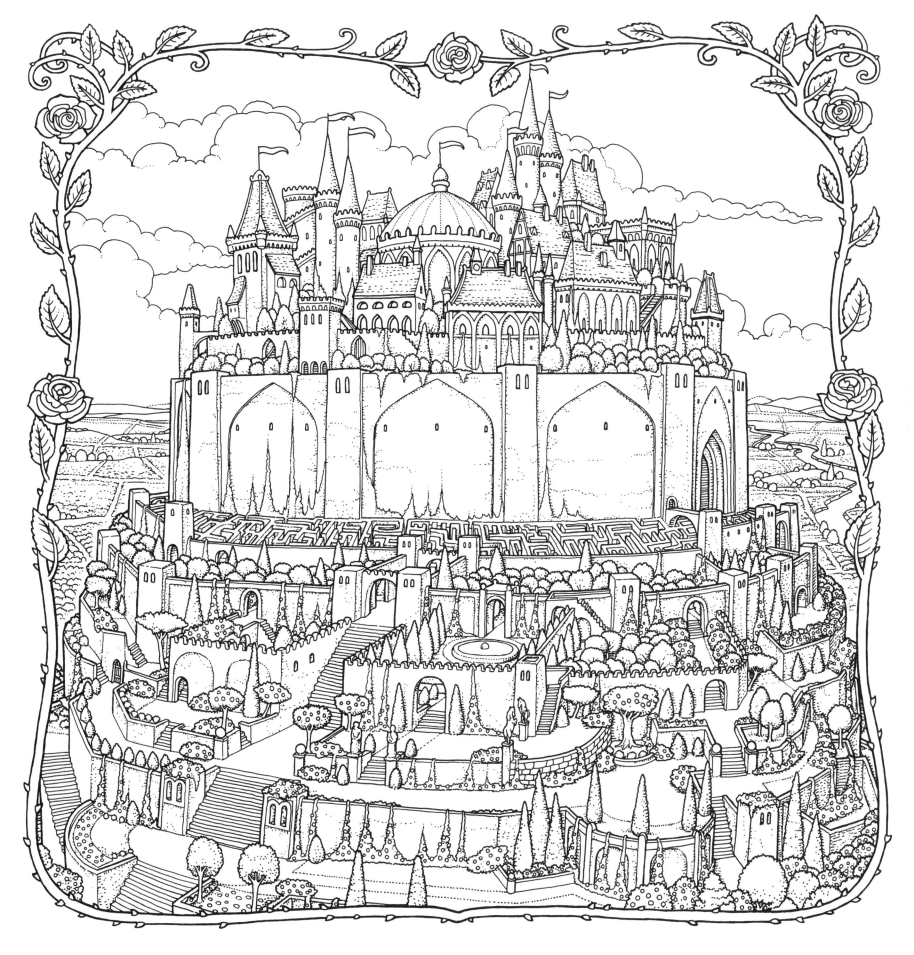

The point of land on which the Greyjoys had raised their fortress had once thrust like a sword into the bowels of the ocean, but the waves had hammered at it day and night until the land broke and shattered, thousands of years past. All that remained were three bare and barren islands and a dozen towering stacks of rock that rose from the water like the pillars of some sea god's temple, while the angry waves foamed and crashed among them.

—*A Clash of Kings*

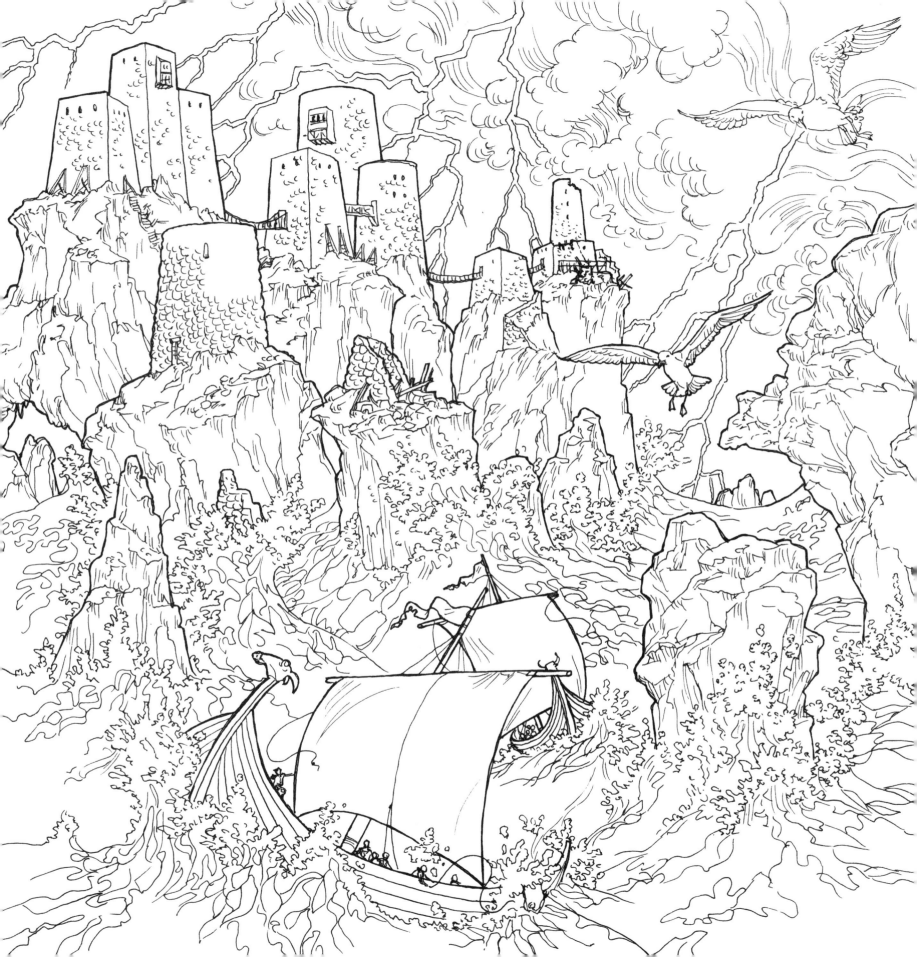

It would be better once they got to Harrenhal, the captives told each other, but Arya was not so certain. She remembered Old Nan's stories of the castle built on fear. Harren the Black had mixed human blood in the mortar, Nan used to say, dropping her voice so the children would need to lean close to hear, but Aegon's dragons had roasted Harren and all his sons within their great walls of stone.

—*A Clash of Kings*

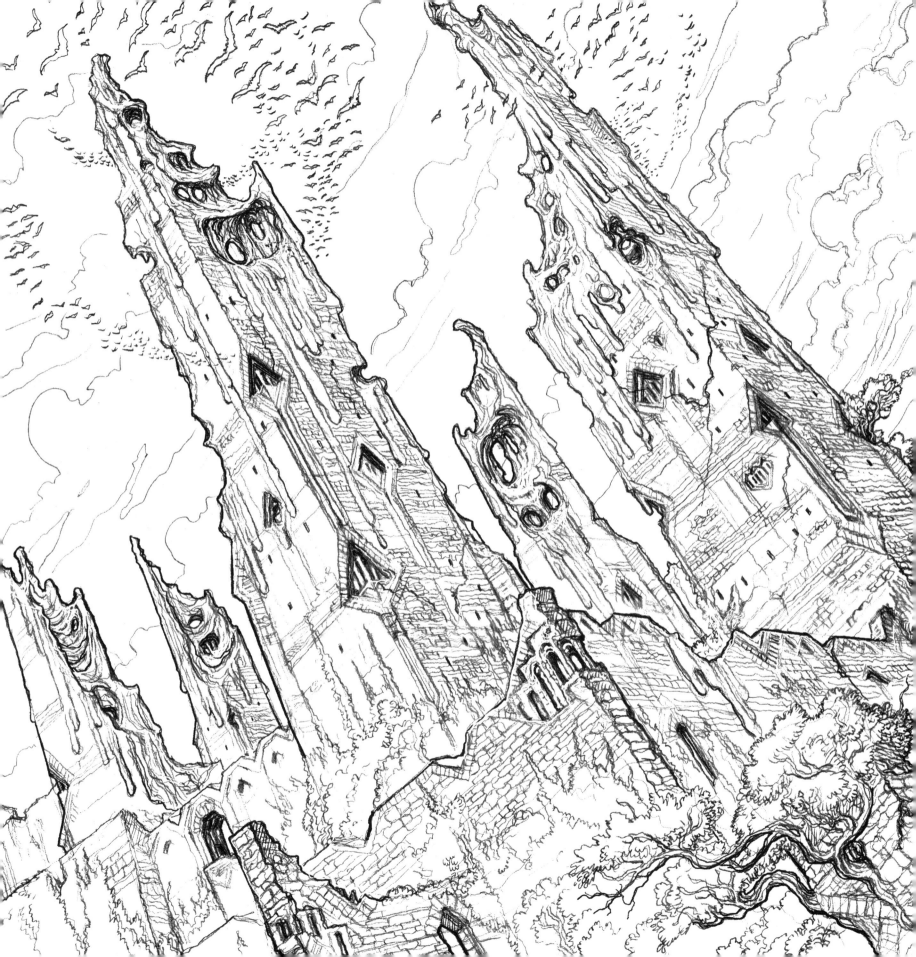

Grim places needed lightening, not solemnity, and Dragonstone was grim beyond a doubt, a lonely citadel in the wet waste surrounded by storm and salt, with the smoking shadow of the mountain at its back.

—*A Clash of Kings*

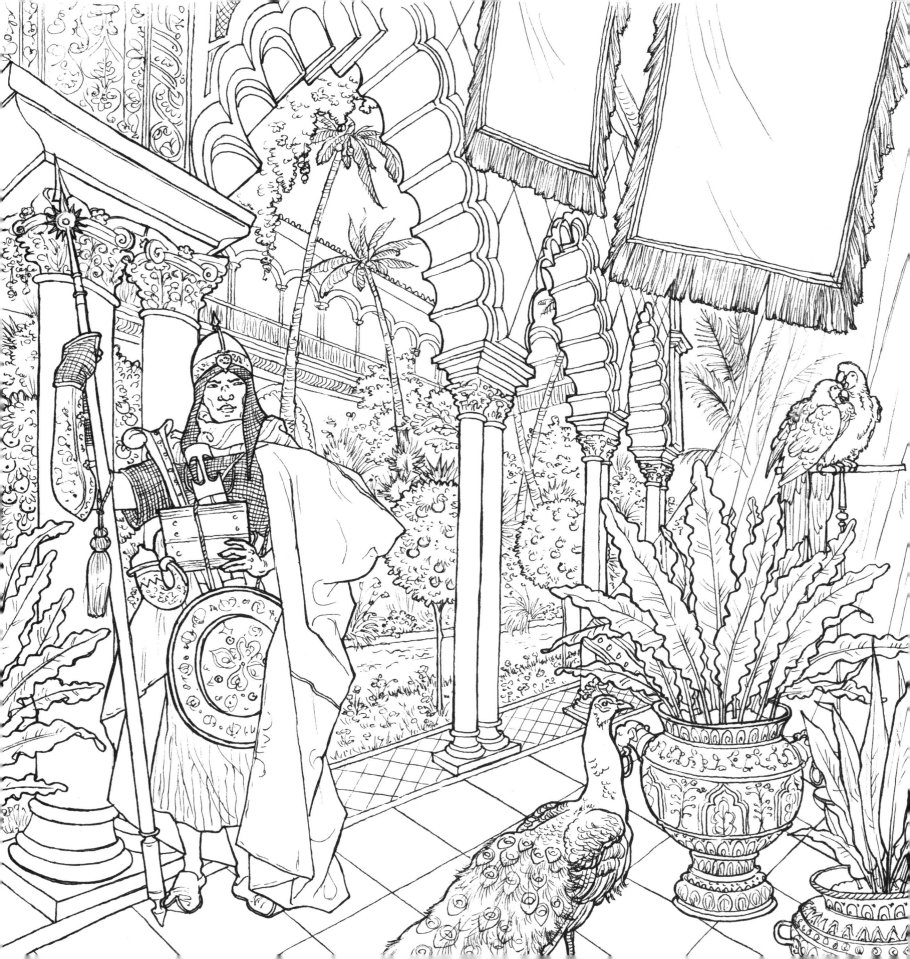

Inside the sept, the great crystal caught the morning light as it streamed through the south-facing window and spread it in a rainbow on the altar.

<div align="right">

—*A Game of Thrones*

</div>

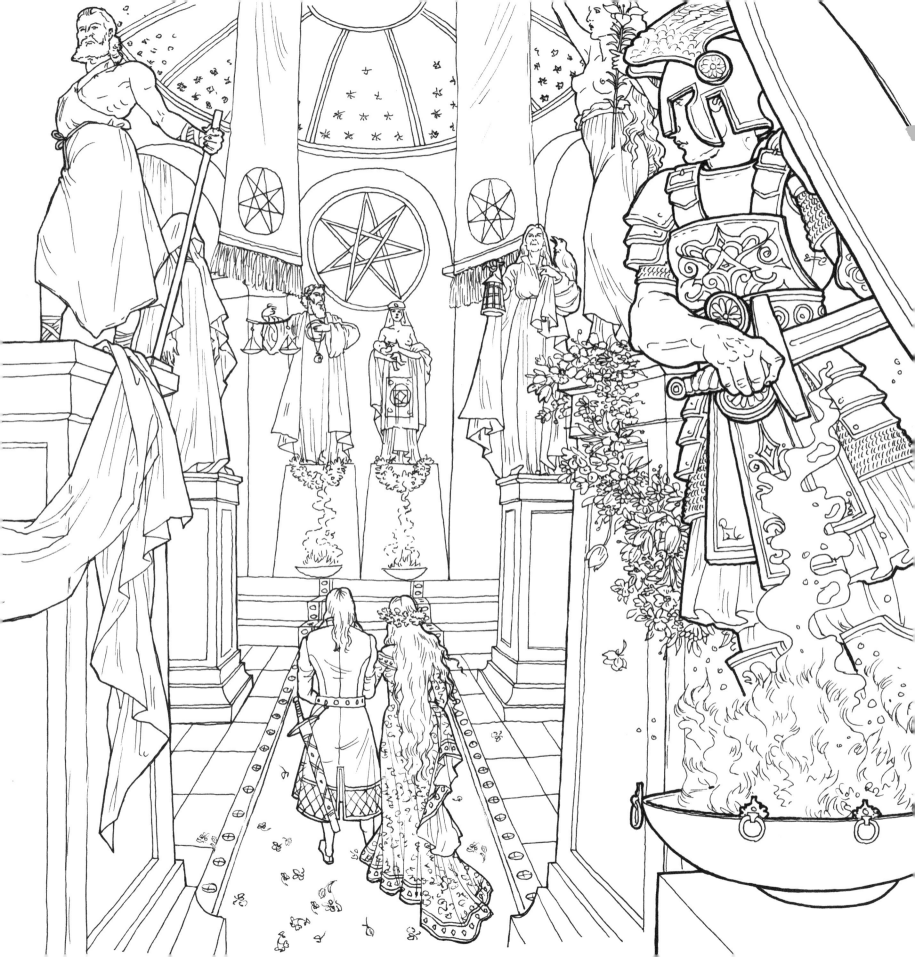

The jousting went all day and into the dusk, the hooves of the great warhorses pounding down the lists until the field was a ragged wasteland of torn earth. A dozen times Jeyne and Sansa cried out in unison as riders crashed together, lances exploding into splinters while the commons screamed for their favorites. Jeyne covered her eyes whenever a man fell, like a frightened little girl, but Sansa was made of sterner stuff.

—*A Game of Thrones*

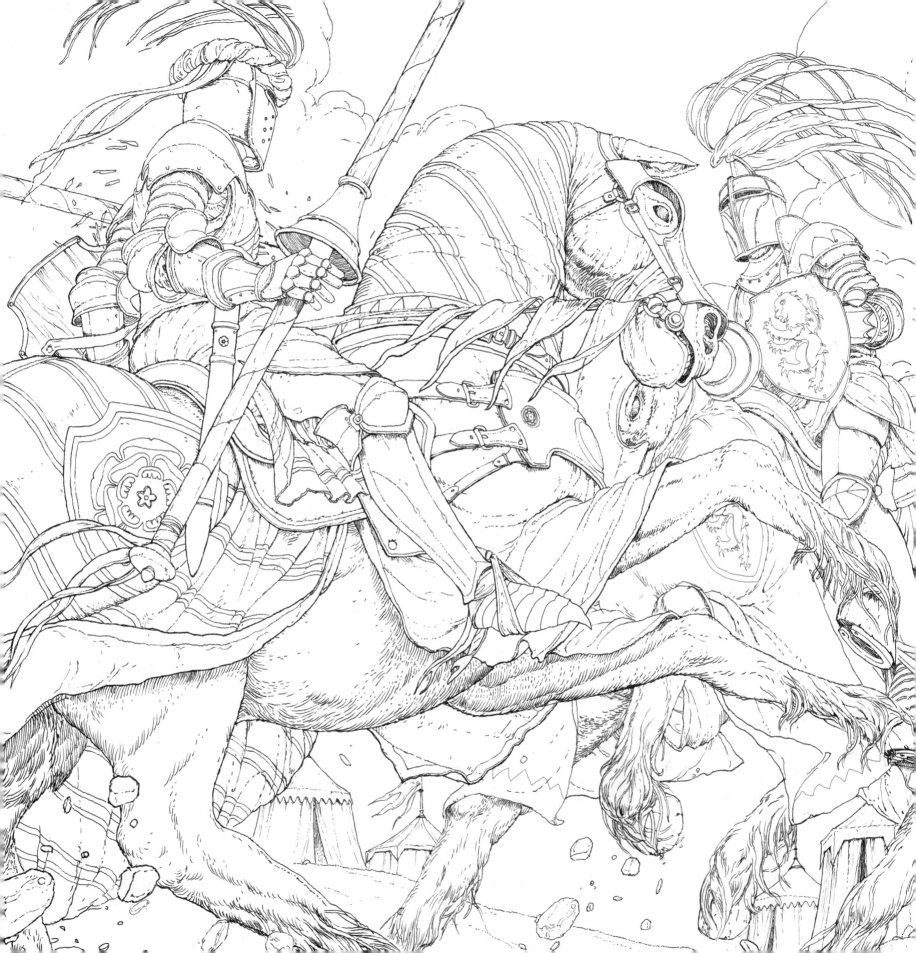

"*Listen!* Listen to the waves! Listen to the god! He is speaking to us, and he says, *We shall have no king but from the kingsmoot!*"

—*A Feast for Crows*

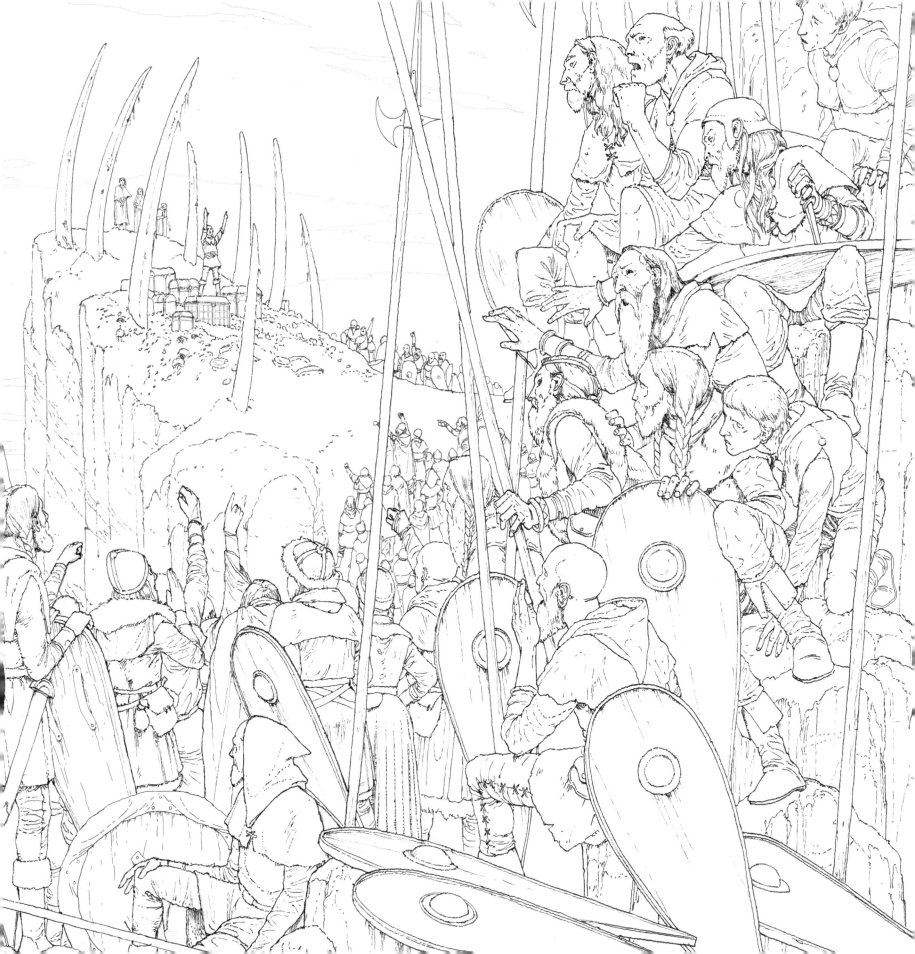

A flash of green caught his eye, ahead and off to port, and a nest of writhing emerald serpents rose burning and hissing from the stern of *Queen Alysanne*. An instant later Davos heard the dread cry of *"Wildfire!"*

—A Clash of Kings

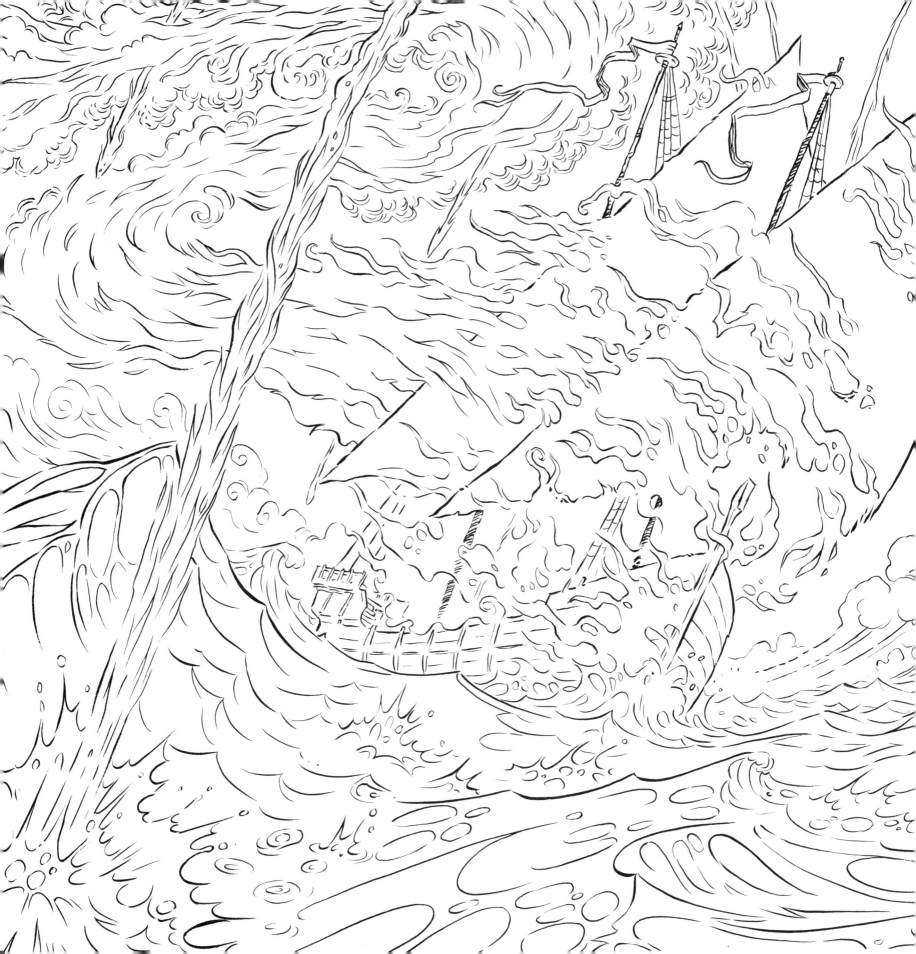

"Once there were two moons in the sky, but one wandered too close to the sun and cracked from the heat. A thousand thousand dragons poured forth, and drank the fire of the sun. That is why dragons breathe flame. One day the other moon will kiss the sun too, and then it will crack and the dragons will return."

—*A Game of Thrones*

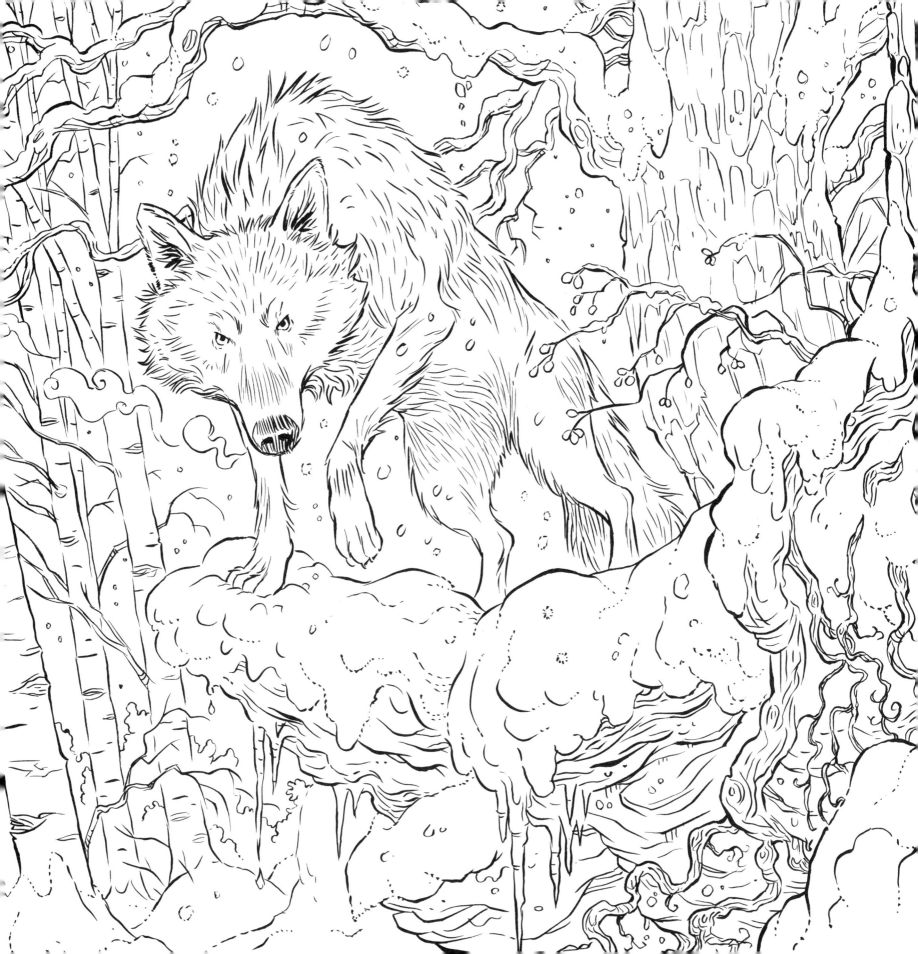

Dark wings, dark words, Old Nan always said, and of late the messenger ravens had been proving the truth of the proverb.

—*A Game of Thrones*

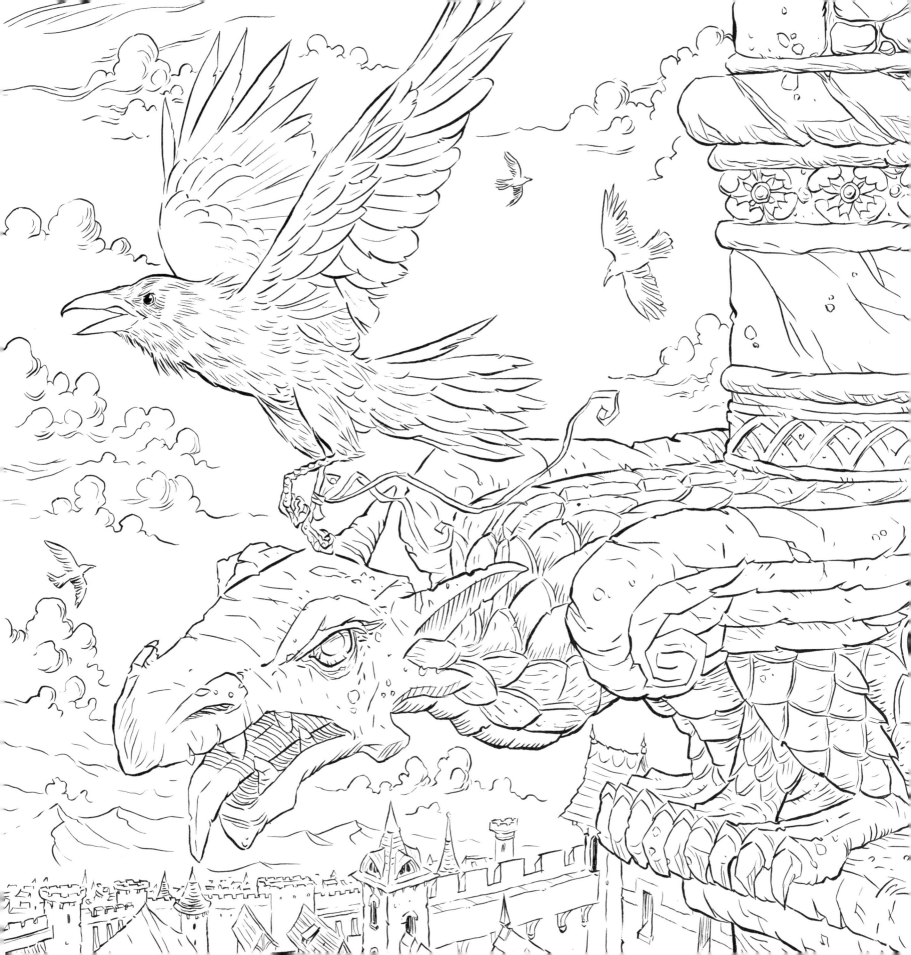

"Our walls are made of wood and painted purple. Our *galleys* are our walls. We need no other."

<div align="right">—A Feast for Crows</div>

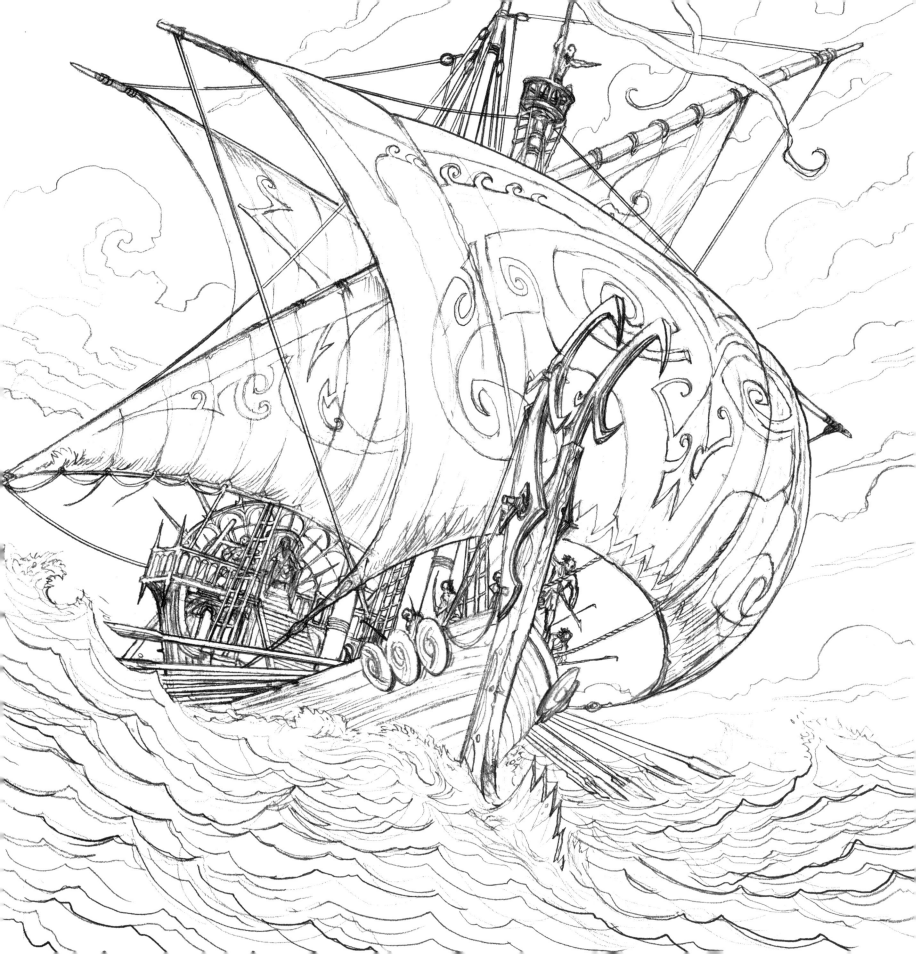

He sat high upon the immense ancient seat of Aegon the Conqueror, an ironwork monstrosity of spikes and jagged edges and grotesquely twisted metal. It was, as Robert had warned him, a hellishly uncomfortable chair.

—*A Game of Thrones*

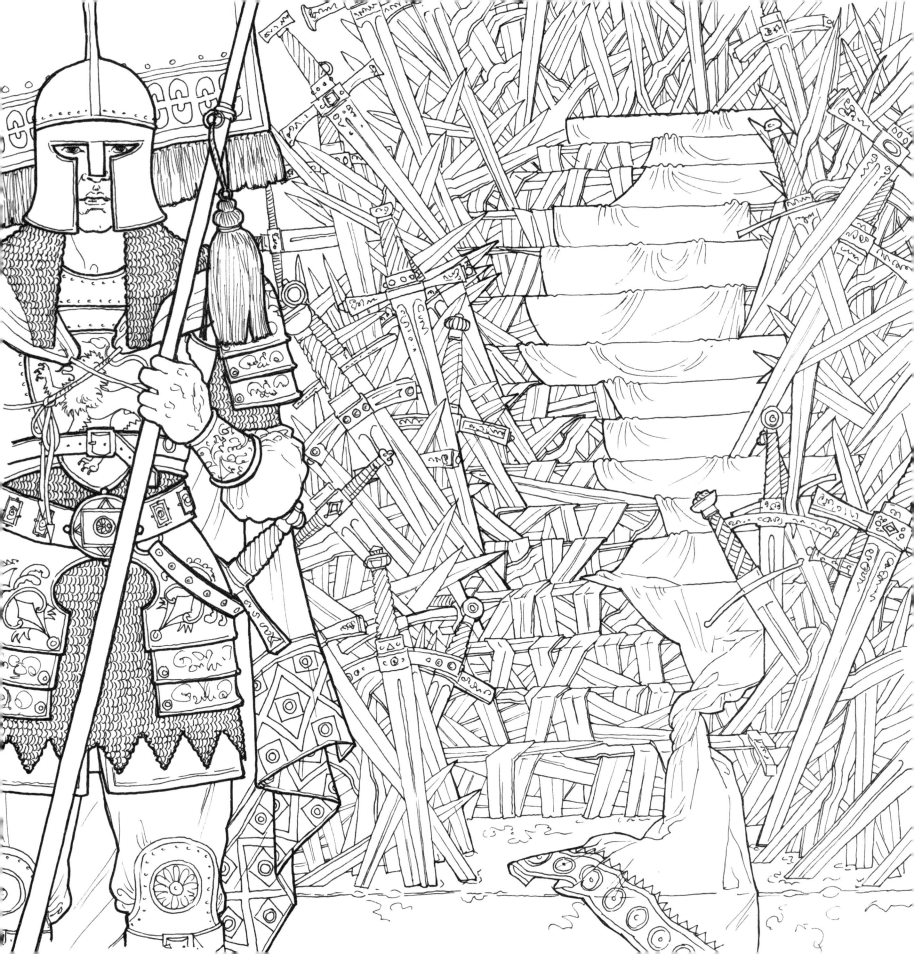

The Hand's private audience chamber was not so large as the king's, nor a patch on the vastness of the throne room, but Tyrion liked its Myrish rugs, wall hangings, and sense of intimacy.

—*A Clash of Kings*

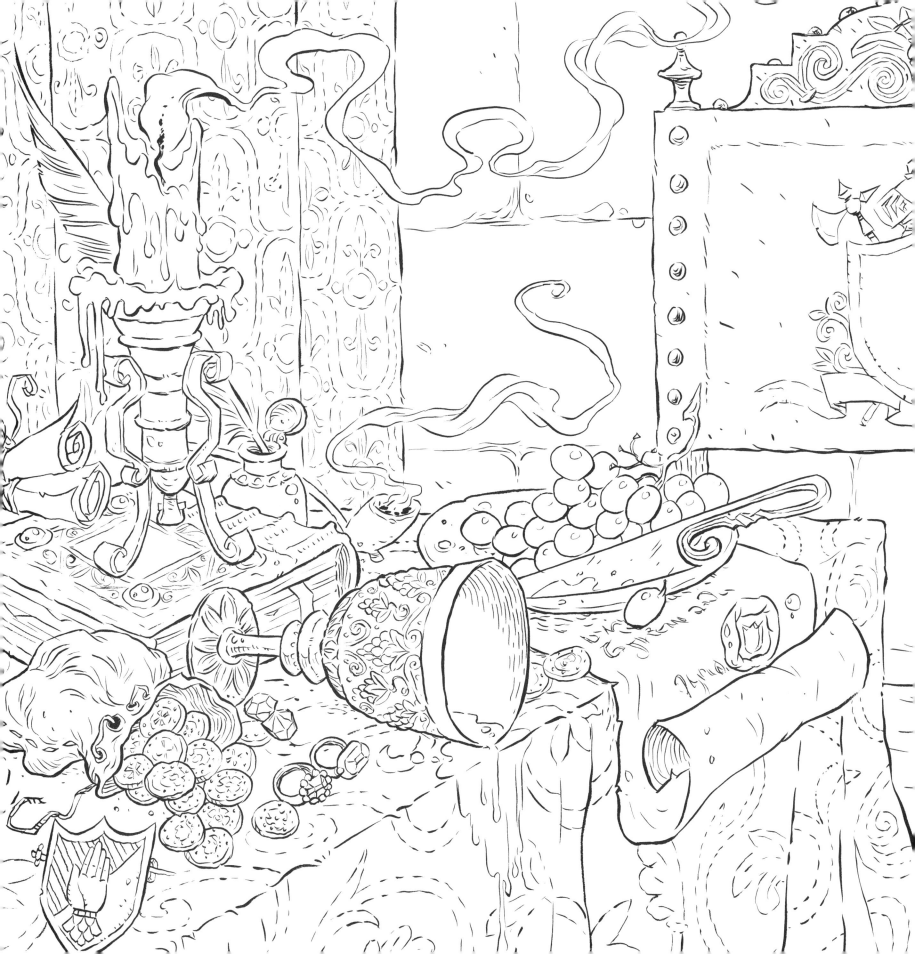

Peacocks were served in their plumage, roasted whole and stuffed with dates.

—A Storm of Swords

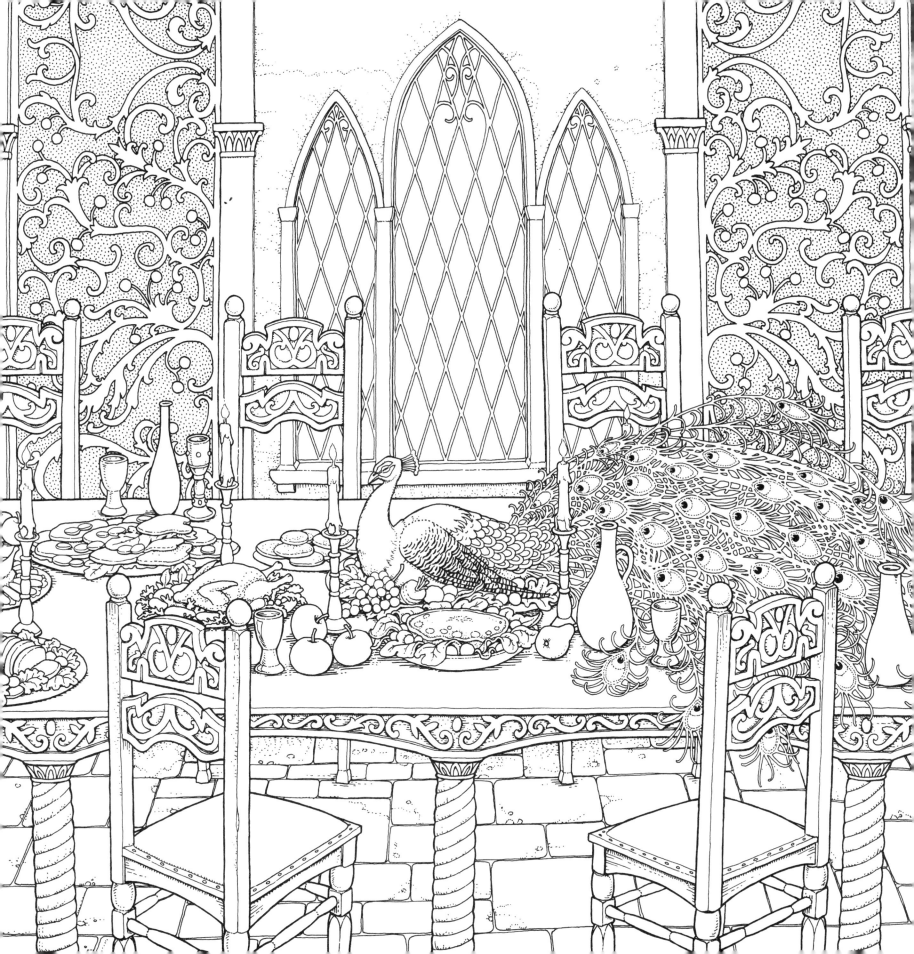

A line of ox carts were rumbling under the portcullis. *Plunder,* she knew at once. The riders escorting the carts spoke in a babble of queer tongues. Their armor glinted pale in the moonlight, and she saw a pair of striped black-and-white zorses. *The Bloody Mummers.* Arya withdrew a little deeper into the shadows, and watched as a huge black bear rolled by, caged in the back of a wagon. Other carts were loaded down with silver plate, weapons and shields, bags of flour, pens of squealing hogs and scrawny dogs and chickens.

—*A Clash of Kings*

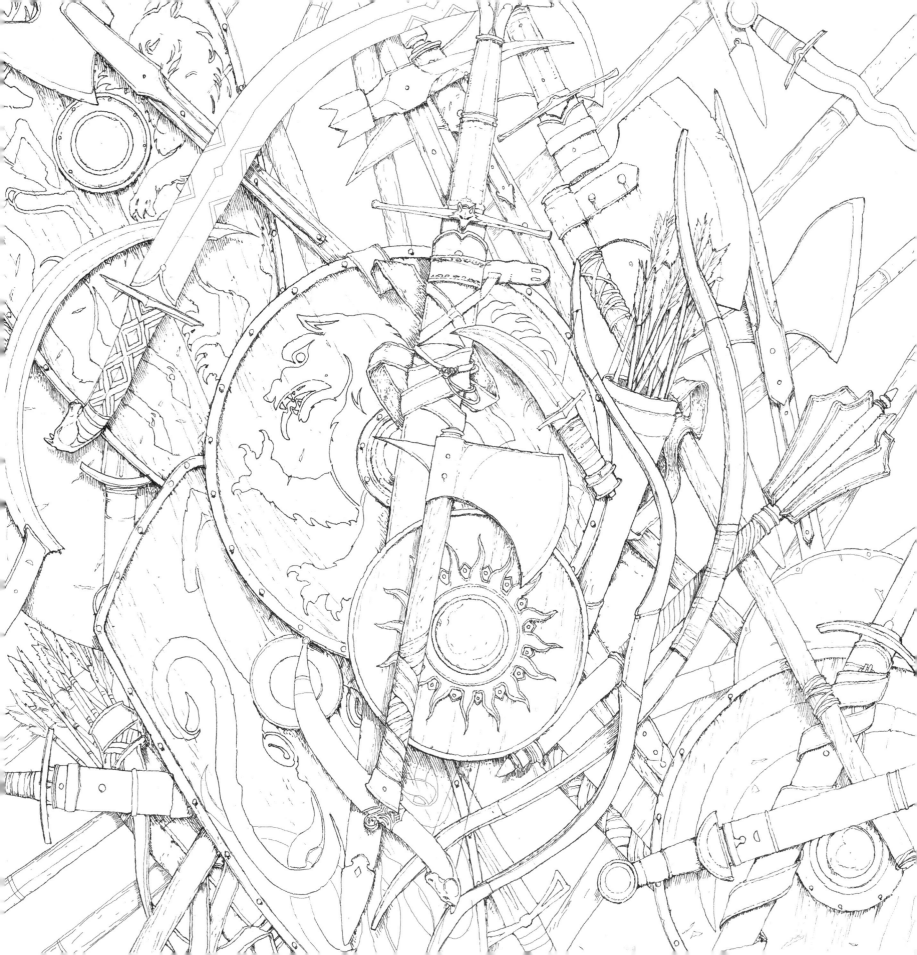

Magister Illyrio murmured a command, and four burly slaves hurried forward, bearing between them a great cedar chest bound in bronze. When she opened it, she found piles of the finest velvets and damasks the Free Cities could produce . . . and resting on top, nestled in the soft cloth, three huge eggs. Dany gasped. They were the most beautiful things she had ever seen, each different than the others, patterned in such rich colors that at first she thought they were crusted with jewels, and so large it took both of her hands to hold one.

—*A Game of Thrones*

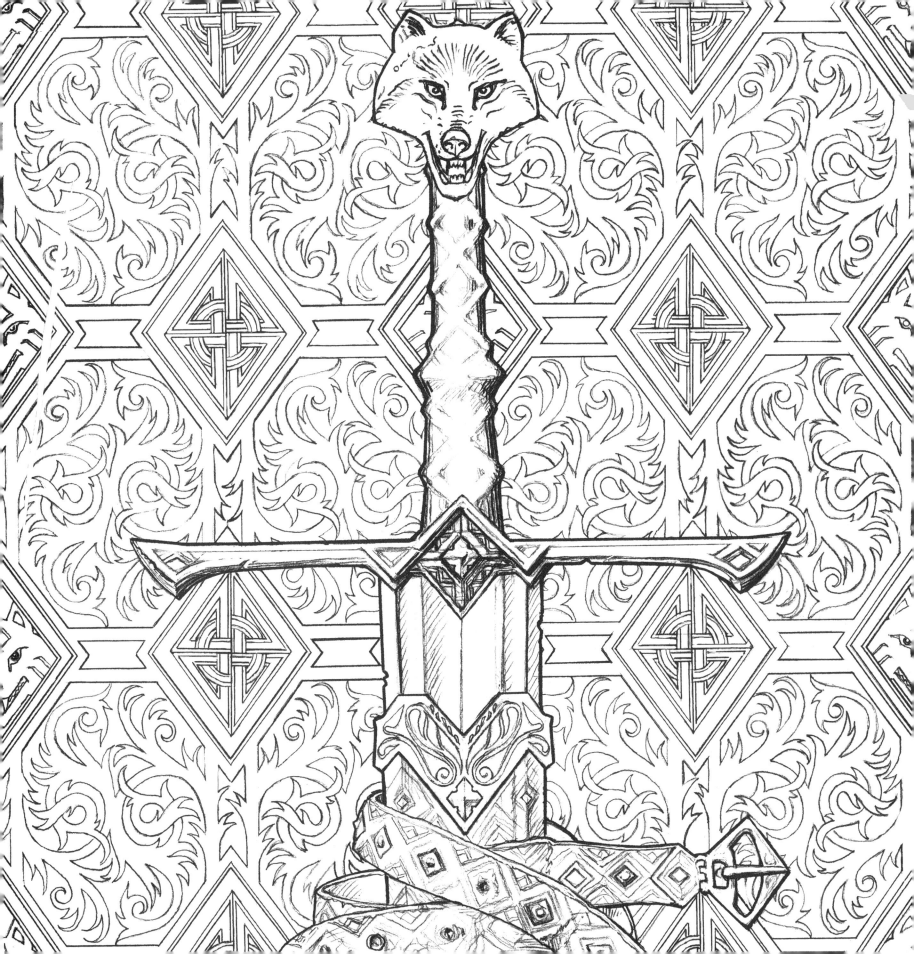

And who are you, the proud lord said, that I must
 bow so low?
Only a cat of a different coat, that's all the truth
 I know
In a coat of gold or a coat of red, a lion still
 has claws,
And mine are long and sharp, my lord, as long and
 sharp as yours.
And so he spoke, and so he spoke, that lord of Castamere,
But now the rains weep o'er his hall, with no one
 there to hear.
Yes now the rains weep o'er his hall, and not
 a soul to hear.

 —A Storm of Swords

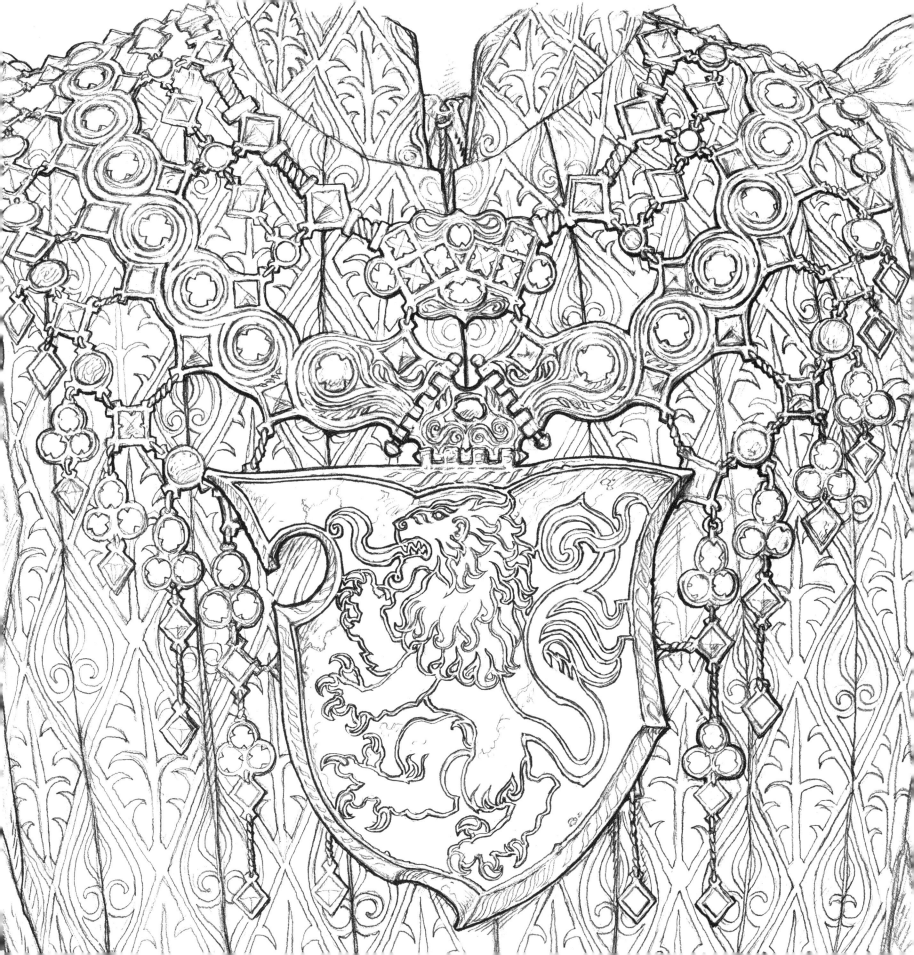

The Great Hall of Winterfell was hazy with smoke and heavy with the smell of roasted meat and fresh-baked bread. Its grey stone walls were draped with banners. White, gold, crimson: the direwolf of Stark, Baratheon's crowned stag, the lion of Lannister.

—*A Game of Thrones*

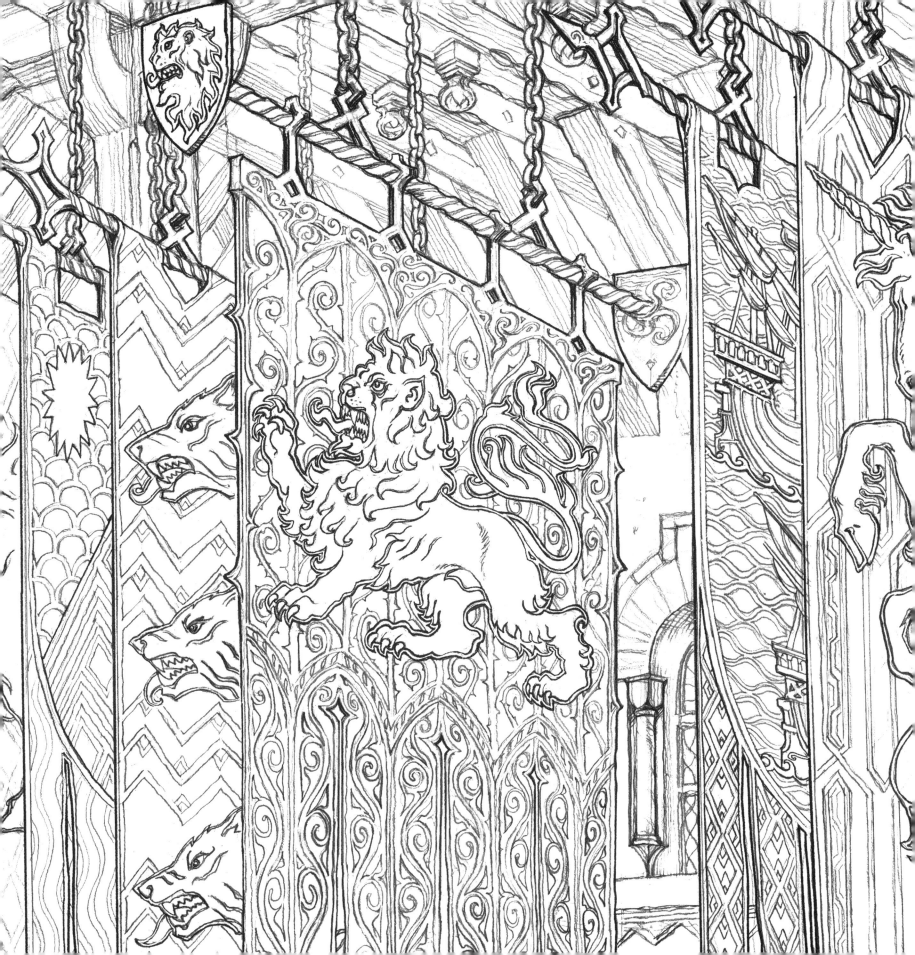

About the Author

GEORGE R. R. MARTIN is the #1 *New York Times* bestselling author of many novels, including the acclaimed series A Song of Ice and Fire—*A Game of Thrones*, *A Clash of Kings*, *A Storm of Swords*, *A Feast for Crows*, and *A Dance with Dragons*—as well as *Tuf Voyaging*, *Fevre Dream*, *The Armageddon Rag*, *Dying of the Light*, *Windhaven* (with Lisa Tuttle), and *Dreamsongs Volumes I* and *II*. He is also the creator of *The Lands of Ice and Fire*, a collection of maps from A Song of Ice and Fire featuring original artwork from illustrator and cartographer Jonathan Roberts, and *The World of Ice & Fire* (with Elio M. García, Jr., and Linda Antonsson). As a writer-producer, Martin has worked on *The Twilight Zone*, *Beauty and the Beast*, and various feature films and pilots that were never made. He lives with the lovely Parris in Santa Fe, New Mexico.

georgerrmartin.com
Facebook.com/GeorgeRRMartinofficial
@GRRMspeaking

About the Artists

John Howe

arenaillustration.com/portfolios/john-howe

JOHN HOWE was born and raised in British Columbia. He studied at the Ecoles des Arts Décoratifs de Strasbourg and now lives and works as an illustrator in Switzerland.

John is a renowned fantasy artist and worked as the lead concept artist on Peter Jackson's film trilogies, *The Lord of the Rings* and *The Hobbit.* John has illustrated many J. R. R. Tolkien titles, calendars, and board games.

Levi Pinfold

levipinfold.com

LEVI PINFOLD has been a fantasy and children's book illustrator for almost ten years, winning the prestigious Kate Greenaway Medal in 2013 for *Black Dog.* His latest picture book, *Greenling,* is to be published in 2106. He lives in Queensland, Australia.

Adam Stower

worldofadam.com

ADAM STOWER is well known for his cover art and black-and-white illustrations. He's also a prolific picture-book artist with more than a dozen titles that he has illustrated, many of which he has also written. He lives in Brighton, England.

Yvonne Gilbert

alanlynchartists.com/#!yvonne-gilbert/c172o

YVONNE GILBERT's work runs the gamut from children's books, postage stamps, posters, and record sleeves. Her love of fairy tales and history has resulted in the design and illustration of many books for publishers worldwide.

Yvonne lives in Toronto, Canada.

Tomislav Tomić

tomislavtomic.com

TOMISLAV TOMIĆ lives with his young family in Croatia. He graduated from the Academy of Fine Arts in Zagreb in 2001. He loves making picture books and began having his work published while still in high school.

His beautiful engravings were featured alongside the work of John Howe and Yvonne Gilbert in the bestselling novelty book *Wizardology* (Templar) and many other "ology" titles.